MARVEL

THE LITTLE BOOK OF

Roy Thomas

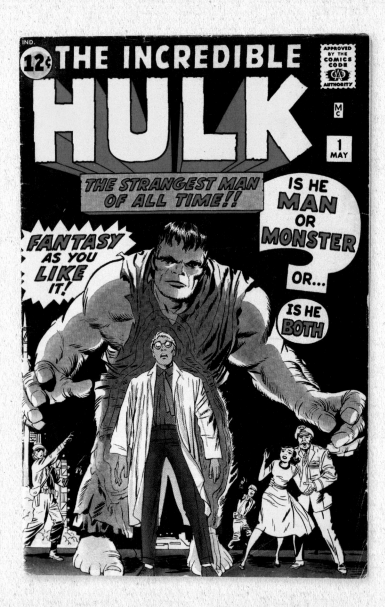

WHAT'S SO GREAT ABOUT THE INCREDIBLE HULK?

Quick! Which of the following Hulk quotes *isn't* from the initial six-issue run of *The Incredible Hulk*?

(a) "With my strength—my power—the *world* is mine!"

(b) *"Hulk smash!"*

(c) "Rick—you wonderful, loyal, empty-headed kid! I *did* it! The ray works!"

(d) "Shut yer yap and listen to me! I'm gonna *pulverize* these crumbs!"

Yep, the answer is (b) *"Hulk smash!"*

In those first half-dozen issues, the Hulk was definitely a concept in search of his final form. He was born, as writer/editor Stan Lee and artist Jack Kirby have both said, as a combination of Jekyll and Hyde and the Frankenstein Monster, created when Dr. Bruce Banner got caught in a gamma bomb explosion.

FF, by the same team, had become a hit, so Stan and publisher Martin Goodman figured their best bet to catch lightning a *second* time was a man-monster just like the Thing—only completely different, of course. Enter—in May 1962—the incredible Hulk.

Originally, they weren't sure how he should look: first he was gray; then he was green.

The Hulk's temperament and speech patterns, as well, were all over the Marvel map: early on, he bombasted like a villain in a melodrama; then his monster side was briefly controlled by Banner's brain—or,

THE INCREDIBLE HULK No. 1
Page 4: *Cover; pencils, Jack Kirby; inks, attributed Jack Kirby; September 1962.* Stan Lee's cover copy playfully teases his audience, questioning what kind of character the Hulk would be. Robert Bruce Banner is struck by the gamma rays of an atomic bomb while rescuing teenager Rick Jones.

TALES TO ASTONISH No. 21
Left: *Interior, "The Silent Screen"; script, Stan Lee; pencils and inks, Steve Ditko; July 1961.* Lee's penchant for the name "Hulk" appears in one of his comics for the second — but not final — time.

A NEW WORLD OF GODS & MONSTERS
Opposite: (left) *Book cover; author, Mary Shelley; Frankenstein; Grosset & Dunlap; 1931.* (right) *Poster, Dr. Jekyll and Mr. Hyde, Paramount Pictures, 1931.* Visually, the Hulk was clearly influenced by the classic Frankenstein movies, while the dichotomy between Bruce Banner and his terrible alter ego seemed inspired by the classic Stevenson story.

briefly, by teenager Rick Jones; then suddenly, slang-slinging syntax took over and he sounded for all the world like his *Fantastic Four* predecessor, the Thing.

Small wonder readers were confused about just who the Hulk was supposed to *be*. After six issues, his comic was canceled.

But he was too great a character to stay dead. Almost immediately, he popped up to battle the FF. When *The Avengers* debuted in mid-1963, he made up one-fifth of its membership — and way over half its combined body weight! He didn't last long as an Avenger, but soon he regained his own solo series, lording it over half the pages of *Tales to Astonish*.

And in 1968, *The Incredible Hulk* again became the unlikely hero of a full-length comic. Since then, he's never looked back. ('Course, that could be because it's hard to turn that thick green neck!)

Under a succession of talented artists and writers, Ol' Jade Jaws moved from triumph to triumph. His series became a spawning-ground for colorful characters: the Glob (the first modern-day

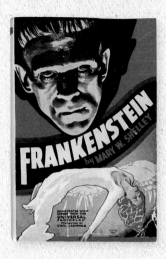

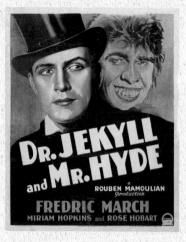

swamp-thing)…Doc Samson (gamma radiation only turned his *hair* green)…and Wolverine, a Canadian mutant whose Adamantium claws gave even the Hulk pause.

He became a cultural icon, however, only when he made the jump to live-action television. Writer/producer/director Kenneth Johnson saw that, for the small screen, he needed to be scaled down a notch, battling evil humans, not toad-men from outer space. As portrayed by green-sprayed bodybuilder Lou Ferrigno, the TV Hulk never spoke; he just snarled and roared—so much for worrying about speech patterns! The smash-hit series added a phrase to the pop-cultural lexicon:

"Don't make me angry! You wouldn't *like* me when I'm angry."

The world liked the Hulk, though. In fact, it *loved* the Hulk—still does.

Over the years, he's undergone many changes in the comics, as befits a guy bombarded by gamma rays. This non-joiner became a founding non-member of Marvel's non-team, *The Defenders*. There's been a Red Hulk—and he was even *gray* again, working as an enforcer named Joe Fixit. For a while, he was Professor Hulk. It was revealed that

A HULK BY ANY OTHER NAME

Opposite: *Interior,* Hulk Special *No. 1; pencils and inks, various; Summer 1968.* It seemed the Hulk's monstrous face had been drawn by just about everyone working for Marvel by the time of his first king-sized special, including Jack Kirby, Dick Ayers, Steve Ditko, Mike "Mickey Demeo" Esposito, John Romita, Marie Severin, Bill Everett, Joe Sinnott, Herb Trimpe, John Buscema, John Verpoorten, and Gil Kane.

Banner was abused as a child, making him a wellspring of repressed rage. Hulk and Banner have even been physically separated into two entities for months, and he's been exiled from Earth and fought monsters, gladiator-style, on the planet Sakaar. The Hulk's had lots of other weird things done to him, too—but this is only a 700-word introduction.

And he's survived it all—*triumphed* over it all—to become one of Marvel's most iconic heroes.

So *that's* what makes the Hulk great. He takes on whatever medium is thrown at him—comics, TV, movies—a whole spectrum of colors and speech quirks and personalities—and he just gets bigger—better—*stronger.*

The Hulk? He's not just great—he's *incredible*!

— *ROY THOMAS*

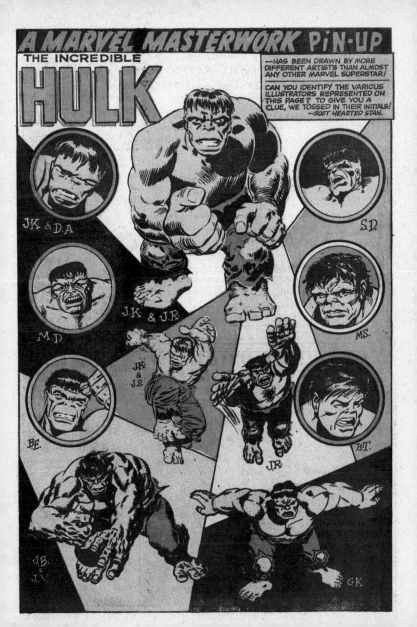

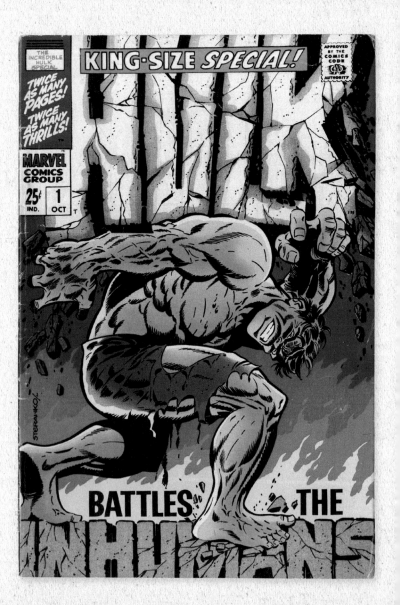

WAS IST SO GROSSARTIG AM UNGLAUBLICHEN HULK?

Raten Sie mal! Welcher der folgenden Sprüche des Hulk stammt *nicht* aus der ersten sechsteiligen Serie *The Incredible Hulk*?

(a) „Mit meiner Kraft – meiner Macht – gehört die Welt mir!"

(b) „Hulk schlägt zu!"

(c) „Rick – du wunderbarer, treuer, hohlköpfiger Junge! Ich hab's geschafft! Der Strahl funktioniert!"

(d) „Halt deine Klappe, und hör mir zu! Aus den Typen mache ich Kleinholz!"

Die richtige Antwortet lautet: (b) „Hulk schlägt zu!"

Sie merken es: In diesem ersten halben Dutzend Ausgaben hatte der Hulk noch nicht zu seiner endgültigen Form gefunden. Autor und Redakteur Stan Lee und der Künstler Jack Kirby konzipierten ihn als Mischung aus Jekyll und Hyde und Frankensteins Monster. Der Hulk entstand, als in unmittelbarer Nähe von Dr. Bruce Banner eine Gammabombe explodierte.

The Fantastic Four, ebenfalls von Lee und Kirby, hatte sich zum Verkaufsschlager entwickelt. Lee und Herausgeber Martin Goodman wollten den Erfolg mit einem zweiten, ähnlichen Monster wie dem FF-Mitglied Thing wiederholen. So kam es, dass im Mai 1962 der unglaubliche Hulk debütierte.

Am Anfang war man sich nicht sicher, wie er aussehen sollte. Erst war er grau, dann grün.

Auch der Charakter und die Sprechweise des Hulk befanden sich auf Schlingerkurs: Zunächst redete er großspurig daher wie ein billiger Schurke. Dann wurde seine Monsterhälfte vorübergehend von Banners Gehirn beherrscht – oder kurz sogar vom jungen Rick Jones. Dann plötzlich redete er Slang wie sein Vorgänger, das Thing.

Kein Wunder, dass die Leser bald nicht mehr wussten, wer oder was der Hulk eigentlich sein sollte. Nach nur sechs Ausgaben wurde seine Serie eingestellt.

Die Figur war jedoch zu großartig, um sie für immer verschwinden zu lassen. Fast postwendend kehrte der Hulk zurück, um gegen die Fantastic Four zu kämpfen. Als Mitte 1963 *The Avengers 1* erschien, bildete der Hulk ein Fünftel des Teams – gemessen am Körpergewicht, sogar mehr als die Hälfte! Ein Avenger war er allerdings nicht lange, stattdessen erhielt er bald eine Soloserie in der einen Hefthälfte von *Tales to Astonish*.

1968 schließlich wurde der Hulk erneut zum Helden einer eigenen, gleichnamigen Comicreihe. Seitdem hat er nur noch nach vorn geschaut. (Was vielleicht auch daher kam, dass sein dicker grüner Hals nicht besonders beweglich ist!)

Zahlreiche talentierte Künstler und Autoren sorgten dafür, dass der Grüne Goliath von Erfolg zu Erfolg stampfte. In seiner Serie debütierten etliche bemerkenswerte Figuren: der Glob (in jener Zeit das erste Sumpfmonster à la Swamp Thing) ... Doc Samson (bei dem die Gammastrahlung nur die *Haare* grün färbte) ... und Wolverine, ein kanadischer Mutant, dessen Adamantium-Krallen sogar dem Hulk zu schaffen machten.

Endgültig berühmt wurde der Hulk, als er in einer Realfilmserie im Fernsehen erschien. Drehbuchautor, Produzent und Regisseur Kenneth Johnson verpasste dem Hulk für den kleinen Bildschirm eine Schrumpfkur: Er kämpfte nicht mehr gegen mächtige Außerirdische, sondern gegen gewöhnliche böse Buben. Der Fernseh-Hulk, gespielt vom grün angemalten Bodybuilder Lou Ferrigno, sagte kein Wort. Er knurrte und fauchte nur – das Problem, sich auf eine bestimmte Sprechweise festzulegen, hat sich somit gar nicht erst gestellt. Stattdessen wurde Banners Standardspruch berühmt:

„Machen Sie mich nicht wütend! Sie würden mich nicht *mögen*, wenn ich wütend bin."

Doch die Zuschauer und Leser mochten den Hulk. Nein, sie *liebten* ihn – und tun es bis heute.

Im Lauf der Jahre hat der Hulk in den Comics etliche Veränderungen durchgemacht, was bei jemandem, der durch Gammastrahlen verwandelt wurde, kein Wunder ist. Der Einzelgänger wurde ein Gründungsmitglied der Defenders, eines Marvel-Teams, das nur zu besonderen Anlässen zusammenkam. Es gab einen Roten Hulk – und er wurde sogar wieder grau und arbeitete als Gangster namens Joe Fixit. Eine Zeit lang war er Professor Hulk. Es wurde enthüllt, dass Banner als Kind missbraucht worden war, was seine unterdrückte Wut erklärte. Monatelang waren der Hulk und Banner sogar in zwei separate Wesen gespalten, er wurde von der Erde verbannt und kämpfte auf dem Planeten Sakaar wie ein Gladiator gegen Monster. Der Hulk hat viele weitere absonderliche Dinge erlebt – unmöglich, sie hier alle aufzuzählen.

Das Entscheidende ist: Er hat alles überlebt – er hat über alles *triumphiert* – und wurde einer von Marvels berühmtesten Helden.

Das ist es, was den Hulk großartig macht. Egal, was man mit ihm anstellt – ob man ihn zum Comic-, Fernseh- oder Kinohelden macht, ob man seine Farbe ändert, seine Sprechweise oder Persönlichkeit –, er wird einfach immer größer ... besser ... *stärker*.

Der Hulk? Er ist nicht nur großartig – er ist *unglaublich!*

– ROY THOMAS

HULK SPECIAL No. 1
Page 10: *Cover; pencils and inks, Jim Steranko with Marie Severin; Summer 1968.* Jim Steranko not only drew the cover but created the logo that was incorporated into the art. Steranko's original cover was altered before publication because the Hulk's face looked too frightening; Marie Severin was brought in to pretty him up.

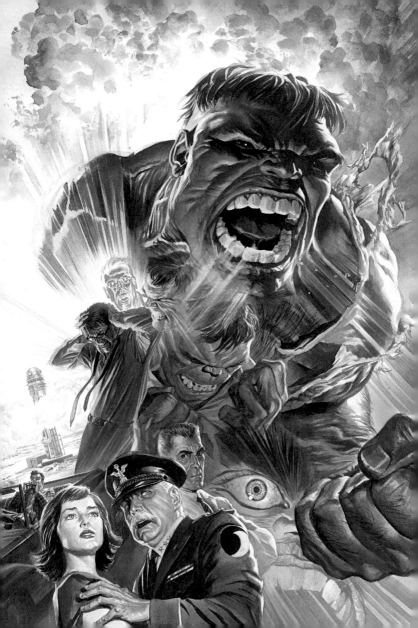

MAIS QU'EST-CE QU'IL A DE SI SPÉCIAL, FINALEMENT, CE HULK ?

Un petit quiz pour commencer : laquelle de ces citations de Hulk n'appartient pas à sa première aventure, publiée sur six numéros dans *The Incredible Hulk* ?

 (a) « Avec ma force... Le monde m'appartient. »

 (b) « Hulk écrase ! »

 (c) « Rick, mon fidèle ami ! J'ai réussi ! »

 (d) « Ferme-la et écoute-moi ! Je vais les pulvériser ! »

Bravo, c'était bien la réponse (b) : « Hulk écrase ! » En vérité, le concept n'en était alors qu'à ses balbutiements, bien loin de sa forme définitive. Avec ce nouveau héros, Stan Lee au scénario et Jack Kirby derrière la planche à dessin expérimentaient une sorte d'hybridation entre Frankenstein d'une part, Dr Jekyll et M. Hyde de l'autre. L'histoire prenait sa source dans une explosion atomique qui entraînait l'exposition accidentelle du physicien Bruce Banner aux radiations gamma, et sa transformation en Titan Vert. Le succès alors récent des Quatre Fantastiques et du personnage de la Chose, imaginés par le même tandem Lee-Kirby, n'était pas étranger à cette décisive métamorphose : afin de rester dans le sens du vent, Stan Lee et Martin Goodman, le patron de Marvel, avaient en effet entrepris de miser une nouvelle fois sur un personnage d'homme-monstre. Il fallait qu'il fût très ressemblant au précédent, et en même temps complètement différent, évidemment... Voilà comment, un beau matin de 1962, l'incroyable Hulk a vu le jour.

Ses créateurs, de fait, ne savaient pas trop à quoi il allait ressembler ; il a d'abord été gris, avant de tourner au vert. Pour le tempérament et le langage, même hésitation : au début le colosse s'exprimait avec une grandiloquence mélodramatique, ensuite on l'a vu passer sous le contrôle mental du Dr Banner puis, tout aussi brièvement, sous celui

du jeune Rick Jones. Et puis brusquement, il s'est mis à adopter une syntaxe peu orthodoxe, truffée d'argot américain, qui n'était pas sans rappeler aux lecteurs son prédécesseur des *Quatre Fantastiques* – lecteurs qu'une personnalité à ce point versatile avait de quoi dérouter. Au terme de ces six premiers numéros, la série fut interrompue.

Mais un personnage comme Hulk n'est pas de ceux qui se satisfont très longtemps du sommeil éternel. Presque immédiatement il est revenu affronter les FF, et quand la bande des *Avengers* se lancera, au milieu de l'année 1963, il en sera l'un des cinq sociétaires – de loin le plus mastoc. Il ne s'attardera pas dans cet habit de Vengeur et récupérera bientôt en solo une série dédiée qui le verra régner sur la moitié des pages de *Tales to Astonish*. Jusqu'à ce que *The Incredible Hulk*, de nouveau, soit gratifié d'un magazine complet. C'était en 1968. Dès lors, il ne fera plus jamais machine arrière – pas facile, il est vrai, de bouger une telle masse! Servi par une pléiade de dessinateurs et de scénaristes plus brillants les uns que les autres, ce bon vieux «Mâchoires de Jade» voguera de triomphe en triomphe et ses tribulations accueilleront une formidable galerie de nouveaux venus. Parmi eux, le Glob, première Créature des Marais de l'ère moderne, Doc Samson, dont l'exposition aux rayons gamma ne verdira que la chevelure, ou Wolverine, mutant canadien aux griffes d'adamantium qui en imposeront à Hulk lui-même...

Ce n'est qu'une fois devenu le héros d'un feuilleton de télévision que le Briseur de Mondes gagnera une fois pour toutes son statut d'icône de la pop culture. À la demande du producteur, auteur et réalisateur Kenneth Johnson, il lui faudra néanmoins, dans son nouveau décor, revoir ses ambitions à la baisse; combattre par exemple de vilains humains bien classiques plutôt que des hommes-crapauds provenant d'autres galaxies. De même, le Hulk cathodique qu'incarnera Lou Ferrigno, culturiste de son état, ne parlera pas: il se contentera de grogner et de rugir. Plus besoin de s'échiner à lui inventer un vocabulaire. La série rencontrera un succès immédiat, ajoutant en la circonstance un nouvel aphorisme au dictionnaire du XXᵉ siècle: «Ne me mettez pas en colère, vous risqueriez de le regretter.»

Le monde, alors, aimait Hulk – ou plutôt l'adorait. Et c'est toujours le cas aujourd'hui. Au fil des ans, le double de Bruce Banner a connu de multiples transformations, comme il sied à un type qui s'est retrouvé comme lui bombardé de rayons gamma. Asocial dans l'âme, il a été l'un des non-membres fondateurs de la non-équipe Marvel baptisée *Les Défenseurs*. On a eu l'occasion de rencontrer un Hulk Rouge, rendu à son gris originel lorsqu'il joua les tueurs à gages sous le nom de Joe Fixit. On a aussi croisé un «professeur Hulk» et appris que Banner, lorsqu'il était enfant, avait subi des sévices qui expliqueraient, chez lui, cette rage si difficilement contenue. Pendant des mois, Bruce et Hulk ont été physiquement séparés en deux entités distinctes. Le géant s'est également vu exiler sur la planète Sakaar où, tel un gladiateur, il est allé défier un à un d'autres monstres. Il lui est arrivé quantité d'aventures bizarroïdes, mais la place qui nous est ici allouée est limitée... Ce qui est sûr, c'est qu'à toutes il a survécu, et en beauté, si l'on peut dire, pour s'imposer comme l'un des héros les plus emblématiques de l'histoire de Marvel.

Voilà ce qui rend Hulk immense. Quels que soient le support – BD, télévision, cinéma – ou la gamme des couleurs, extravagances verbales et personnalités qui lui ont tour à tour été assignées, il n'a jamais cessé, au final, de s'en trouver plus grand – plus fort.

Hulk ? Il n'est pas seulement grand. Il est incroyable !

– ROY THOMAS

SAVAGE HULK No. 1
Page 14: *Variant cover; art, Alex Ross; August 2014.* Classicist Alex Ross painted a stirring tableau of Hulk history for the Marvel 75th Anniversary variant cover initiative.

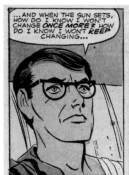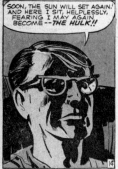

THE INCREDIBLE HULK No. 1

This spread: *Interiors, "The Coming of the Hulk!"; script,
Stan Lee; pencils, Jack Kirby; inks, Paul Reinman; May 1962.*
The Hulk was only gray for the first issue. Stan Goldberg — a
long-time Lee collaborator on *Millie the Model* and Marvel's
primary colorist — has said that he wanted the Hulk to be
green from the start, but writer/editor Stan Lee opted for
gray. Gray did not print consistently in the comics at that time,
and "Stan G." recalled that the Hulk even appeared green
in one panel of this first issue, before the giant became
emerald for good.

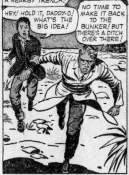

UNMINDFUL OF HIS OWN SAFETY, THE WORLD-FAMOUS NUCLEAR SCIENTIST DASHED TO THE TEEN-AGER AND SPED WITH HIM TOWARDS A NEARBY TRENCH!

HEY! HOLD IT, DADDY-O! WHAT'S THE BIG IDEA?!

NO TIME TO MAKE IT BACK TO THE BUNKER! BUT THERE'S A DITCH OVER THERE!

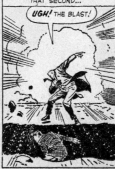

FRANTICALLY, DR. BANNER HURLED RICK JONES INTO THE CREVICE, WHERE THE TEEN-AGER WAS SHIELDED FROM THE MYSTERIOUS, MENACING GAMMA RAYS! BUT, AT THAT SECOND...

UGH! THE BLAST!

STANDING IN THE OPEN, EXPOSED AND UNSHELTERED, THE HEROIC BRUCE BANNER ABSORBED THE FULL IMPACT OF THE NUCLEAR EXPLOSION, EVEN THOUGH THE CENTER OF THE BLAST WAS A GOOD FIVE MILES AWAY!

HIS EAR-PIERCING SCREAMS FILLED THE DESERT AIR, AS THE SCIENTIST LOST ALL SENSE OF TIME AND SPACE... AS A STRANGE, AWESOME CHANGE TOOK PLACE IN THE ATOMIC STRUCTURE OF HIS BODY!

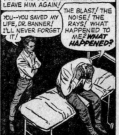

A SHORT TIME LATER, DR. BANNER REGAINED CONSCIOUSNESS IN A ROOM AT THE BASE HOSPITAL, WITH THE BOY WHOSE LIFE HE HAD SAVED STANDING BY! THE BOY, RICK JONES, WHO WAS DESTINED NEVER TO LEAVE HIM AGAIN!

YOU--YOU SAVED MY LIFE, DR. BANNER! I'LL NEVER FORGET IT!

THE BLAST! THE NOISE! THE RAYS! WHAT HAPPENED TO ME? WHAT HAPPENED?

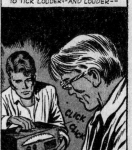

AND THEN, AS THE SUN SET, AS THOUGH IN ANSWER TO BRUCE BANNER'S ANGUISHED QUESTION, THE GEIGER COUNTER, ON A NEARBY TABLE, BEGAN TO TICK LOUDER--AND LOUDER--

CLICK CLICK

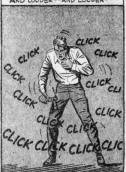

AND LOUDER--AND LOUDER--

CLICK CLICK CLICK CLICK CLICK CLICK CLICK CLI CLICK CLICK CLICK CLICK CLICK CLICK CLIC

AND LOUDER--

CLICK CLICK CLICK CLICK CLICK CLICK CLICK

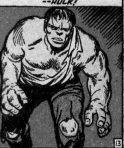

UNTIL THE MAN WHO HAD BEEN DOCTOR BRUCE BANNER HAD TURNED INTO THE MOST DANGEROUS LIVING CREATURE ON EARTH--THE INCREDIBLE --HULK!

13

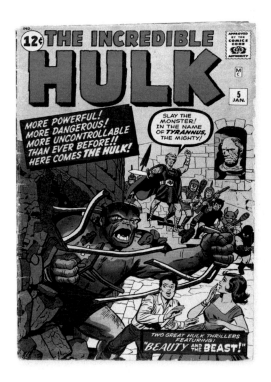

THE INCREDIBLE HULK No. 3

Opposite: *Interior, "The Origin of the Hulk!"; script, Stan Lee; pencils, Jack Kirby; inks, Dick Ayers; May 1962.* A Marvel tradition begins: the origin recap!

THE INCREDIBLE HULK No. 5

Above: *Cover; pencils, Jack Kirby; inks, Dick Ayers; January 1963.*

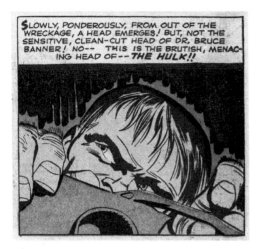

Slowly, ponderously, from out of the wreckage, a head emerges! But, not the sensitive, clean-cut head of Dr. Bruce Banner! No-- this is the brutish, menacing head of--*THE HULK!!*

THE INCREDIBLE HULK No. 1

Above: *Interior, "The Coming of the Hulk!"; script, Stan Lee; pencils, Jack Kirby; inks, Paul Reinman; May 1962.* The Hulk was not an instant success when his series debuted. In fact, his book was canceled after only six issues. Perhaps it was the inconsistent nature of his metamorphosis — initially tied to external forces such as the sunrise, then a machine. His battleship gray hide lasted but one issue, the reproduction of which, Stan Goldberg lamented, fluctuated so much that it even appeared green in this fateful panel. Whatever the reason, Lee saw the potential in the emerald goliath, and for 18 months Hulk fought his way through the rest of Marvel's titles until finally landing his own feature in *Tales to Astonish*, where Ditko added the anger management issues, along with a strong supporting cast.

THE INCREDIBLE HULK No. 2

Opposite: *Interior, "Terror of the Toad Men!"; script, Stan Lee; pencils, Jack Kirby; inks, Steve Ditko; July 1962.* Ditko's detailed inking brings a sense of dread to the proceedings — in this case a classic Kirby slugfest, the likes of which hadn't been seen since Captain America's glory days in the early 1940s. Ditko was one of Kirby's early inkers in the pre-hero Atlas era, an all-star team that continued occasionally into the Marvel Age.

PART 5 THE END OF THE HULK?

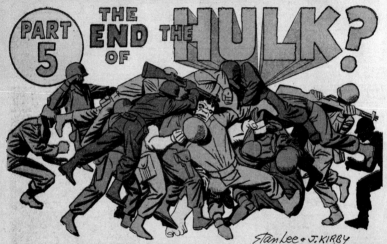

Stan Lee & J. Kirby

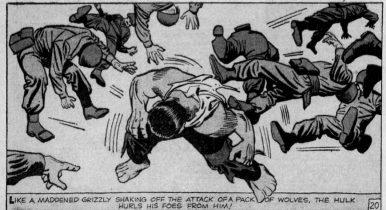

LIKE A MADDENED GRIZZLY SHAKING OFF THE ATTACK OF A PACK OF WOLVES, THE HULK HURLS HIS FOES FROM HIM!

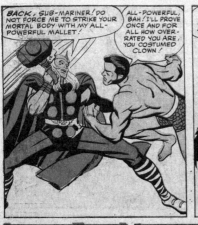

BACK, SUB-MARINER! DO NOT FORCE ME TO STRIKE YOUR MORTAL BODY WITH MY ALL-POWERFUL MALLET!

ALL-POWERFUL, BAH! I'LL PROVE ONCE AND FOR ALL HOW OVER-RATED YOU ARE, YOU COSTUMED CLOWN!

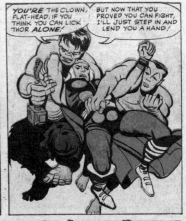

YOU'RE THE CLOWN, FLAT-HEAD, IF YOU THINK YOU CAN LICK THOR ALONE!

BUT NOW THAT YOU PROVED YOU CAN FIGHT, I'LL JUST STEP IN AND LEND YOU A HAND!

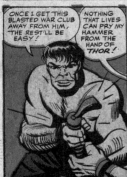

ONCE I GET THIS BLASTED WAR CLUB AWAY FROM HIM, THE REST'LL BE EASY!

NOTHING THAT LIVES CAN PRY MY HAMMER FROM THE HAND OF THOR!

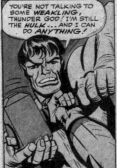

YOU'RE NOT TALKING TO SOME WEAKLING, THUNDER GOD! I'M STILL THE HULK... AND I CAN DO ANYTHING!

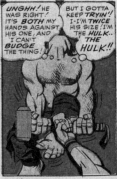

UNGHH! HE WAS RIGHT! IT'S BOTH MY HANDS AGAINST HIS ONE, AND I CAN'T BUDGE THE THING!

BUT I GOTTA KEEP TRYIN'! I-I'M TWICE HIS SIZE! I'M THE HULK.. THE HULK!!

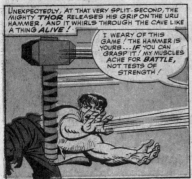

UNEXPECTEDLY, AT THAT VERY SPLIT-SECOND, THE MIGHTY THOR RELEASES HIS GRIP ON THE URU HAMMER, AND IT WHIRLS THROUGH THE CAVE LIKE A THING ALIVE!

I WEARY OF THIS GAME! THE HAMMER IS YOURS... IF YOU CAN GRASP IT! MY MUSCLES ACHE FOR BATTLE, NOT TESTS OF STRENGTH!

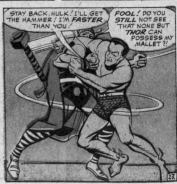

STAY BACK, HULK! I'LL GET THE HAMMER! I'M FASTER THAN YOU!

FOOL! DO YOU STILL NOT SEE THAT NONE BUT THOR CAN POSSESS MY MALLET?!

26

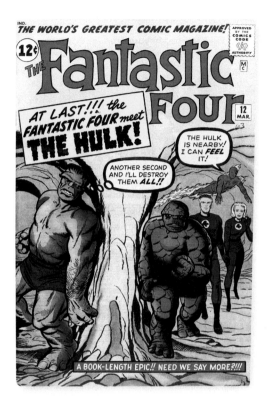

AVENGERS No. 3

Opposite: *Interior, "The Avengers Meet…Sub-Mariner!"; script, Stan Lee; pencils, Jack Kirby; inks, Paul Reinman; January 1964.* The Hulk's second appearance outside of his title came as an inaugural member of the Avengers. Unfortunately for all involved, Hulk spent as much time bickering and brawling with his teammates as working together.

FANTASTIC FOUR No. 12

Above: *Cover; pencils, Jack Kirby; inks, Dick Ayers; March 1963.* You can't keep a good Hulk down. *The Incredible Hulk* was canceled after six issues, but that same month he appeared in *Fantastic Four* No. 12, giving fans the first — but nowhere near the last — fight between the Hulk and the Thing.

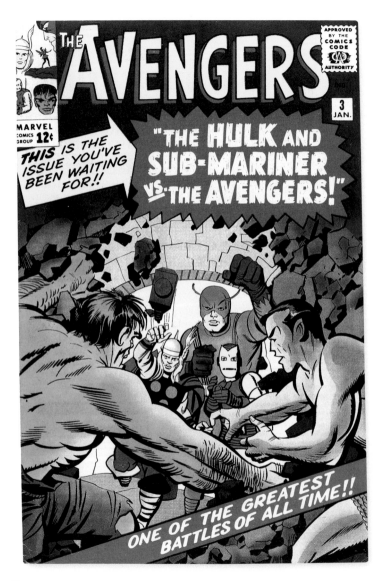

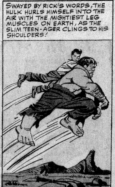

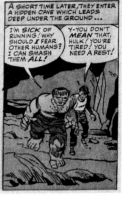

AVENGERS No. 3

Opposite: *Cover; pencils, Jack Kirby; inks, Paul Reinman; January 1964.* Even more shocking than the Hulk uniting with the Avengers was — by the third issue no less — when he stood against them. The Sub-Mariner exploited the divisions between the Hulk and his mistrustful allies in the Avengers to recruit the gamma-green giant in his war of vengeance against the surface world.

SIDEKICK RICK

Above: *Interior, "The Avengers Meet…Sub-Mariner!"; script, Stan Lee; pencils, Jack Kirby; inks, Paul Reinman; January 1964.* In his early adventures, the Hulk had his very own sidekick in Rick Jones. The teenager foolishly trespassed on the gamma bomb testing range, drawing Bruce Banner out of his bunker to save him (and you know how *that* story ended!). With a tragic sense of obligation to his fated new friend, Jones stood by the Hulk at his absolute worst to repay a debt he would never be able to fully pay off.

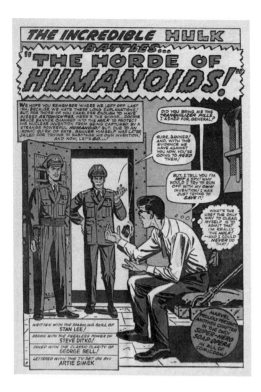

TALES TO ASTONISH No. 60
Above: *Interior, "The Horde of Humanoids!"; script, Stan Lee; pencils, Steve Ditko; inks, George Roussos; January 1964.* Ditko had penciled the final *Incredible Hulk* issue, and he was back on board to draw the Hulk installments in Hulk's new home, *Tales to Astonish.*

TALES TO ASTONISH No. 59
Opposite: *Cover; pencils, Jack Kirby; inks, Sol Brodsky; September 1964. Tales to Astonish* had effectively been a Giant-Man and the Wasp book for several months when the Hulk made a combative guest appearance in No. 59. The "team-up" was a bit of foreshadowing, as with the following issue Giant-Man and the Wasp would make room to include an ongoing Hulk feature.

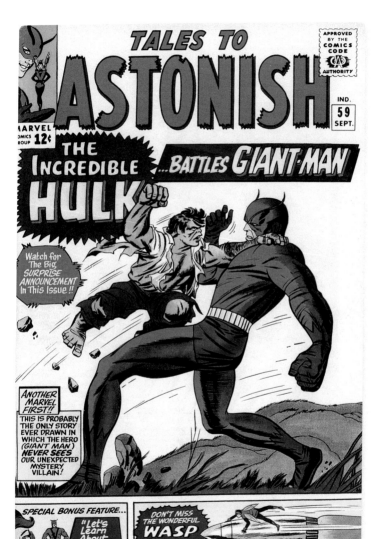

29

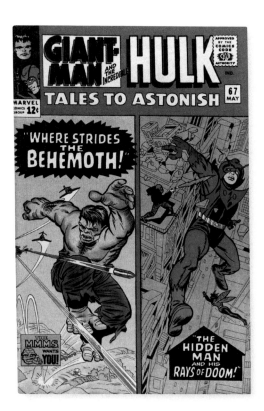

TALES TO ASTONISH No. 67
Above: *Cover; pencils, Jack Kirby; inks, Chic Stone; May 1965.*

TALES TO ASTONISH No. 75
Opposite: *Cover; pencils, Jack Kirby and Gene Colan; inks,*
Vince Colletta; January 1966.

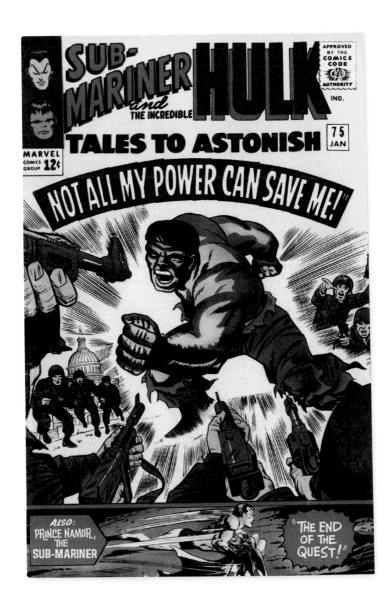

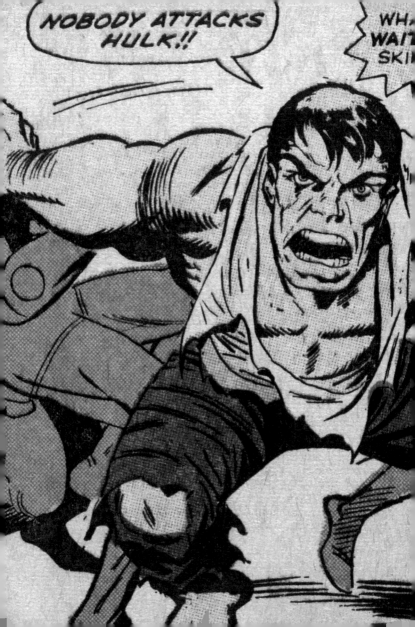

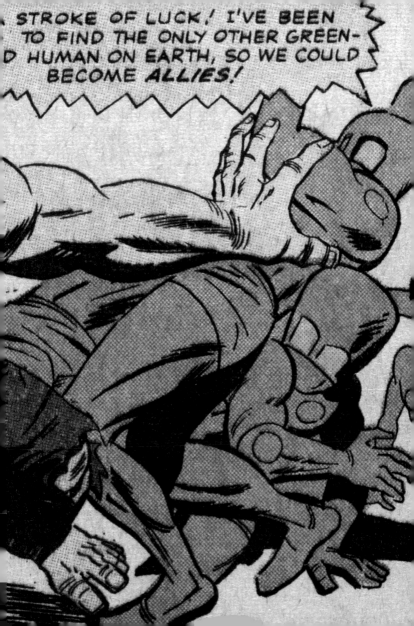

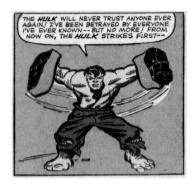

TALES TO ASTONISH No. 68

Previous spread: *Interior, "Back from the Dead!"; script, Stan Lee; pencils, Jack Kirby; inks, Mike Esposito; June 1965.* "Many fans have commented about the fact that the Hulk, as depicted by Jack Kirby, always seemed incredibly savage and powerful, while Steve Ditko's version — although equally powerful — seemed to portray more thoughtful, more cerebral. I'm tempted to say that Steve himself is a very thoughtful guy, but there's no way I'm gonna call Kirby a savage, so we'll just let it go at that." — Stan Lee

FANTASTIC FOUR No. 26

Above: *Interiors, "The Avengers Take Over!"; script, Stan Lee; pencils, Jack Kirby; inks, Sol Brodsky; May 1964.* With concrete rubble in his mighty grip, the Hulk claps his hands together, creating a senses-shattering sonic boom!

"THE AVENGERS TAKE OVER!"

Opposite: *Interior, "The Avengers Take Over!"; script, Stan Lee; pencils, Jack Kirby; inks, Sol Brodsky; May 1964.* Reed Richards is in a coma, laid low by a microbial disease. Sue Storm refuses to leave his side. And Johnny Storm has been sent to the hospital after a brutal battle with the Hulk. The only one left standing to face him is the Thing, on his last legs after an epic fight. But if the FF can't face down a rampaging Hulk, who will? The Avengers, that's who! The Marvel Age reaches peak awesomeness in this commingling of its biggest characters.

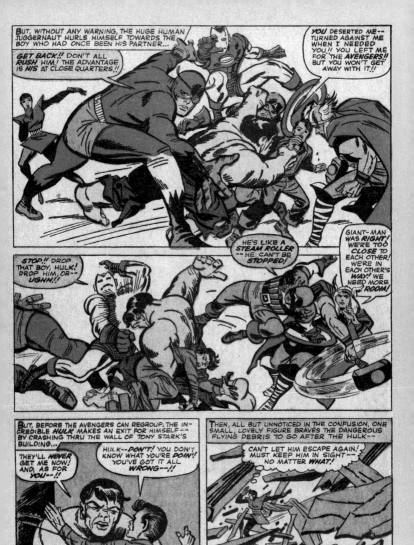

BUT, WITHOUT ANY WARNING, THE HUGE HUMAN JUGGERNAUT HURLS HIMSELF TOWARDS THE BOY WHO HAD ONCE BEEN HIS PARTNER...

GET BACK!! DON'T ALL *RUSH* HIM! THE ADVANTAGE IS *HIS* AT CLOSE QUARTERS!!

YOU DESERTED ME-- TURNED AGAINST ME WHEN I NEEDED YOU!! YOU LEFT ME FOR *THE AVENGERS!!* BUT YOU WON'T GET AWAY WITH IT!!

HE'S LIKE A *STEAM ROLLER* -- HE *CAN'T* BE *STOPPED!*

GIANT-MAN WAS *RIGHT!* WE'RE TOO *CLOSE* TO EACH OTHER! WE'RE IN EACH OTHER'S *WAY!* WE *NEED* MORE *ROOM!*

STOP.!! DROP THAT BOY, HULK! DROP HIM, OR-- *UGHH!!*

BUT, BEFORE THE AVENGERS CAN REGROUP, THE IN-CREDIBLE *HULK* MAKES AN EXIT FOR HIMSELF-- BY CRASHING THRU THE WALL OF TONY STARK'S BUILDING...

THEY'LL *NEVER* GET ME NOW! AND, AS FOR *YOU--!!*

HULK--*DON'T!* YOU DON'T KNOW WHAT YOU'RE *DOIN'!* YOU'VE GOT IT ALL *WRONG--!!*

THEN, ALL BUT UNNOTICED IN THE CONFUSION, ONE SMALL, LOVELY FIGURE BRAVES THE DANGEROUS FLYING DEBRIS TO GO AFTER THE HULK--

CAN'T LET HIM ESCAPE AGAIN! MUST KEEP HIM IN SIGHT-- NO MATTER *WHAT!*

10

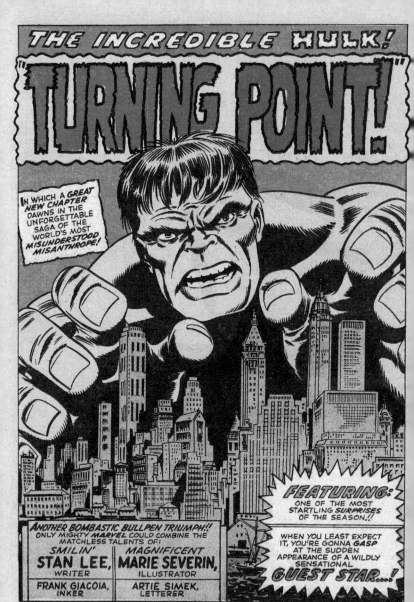

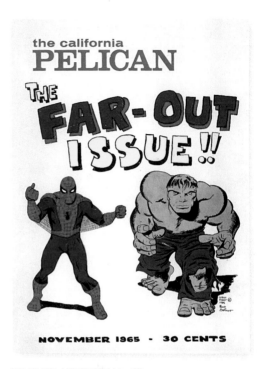

TALES TO ASTONISH No. 92

Opposite: *Interior, "Turning Point!"; script, Stan Lee; pencils, Marie Severin; inks, Frank Giacoia; June 1967.* When Marie Severin took over the Hulk her version was less threatening than the interpretations by Jack Kirby, Bill Everett, or Gil Kane. She softened his features, and gave a more cartoonish feel to her pencils, to great popular success.

MARVEL GOES TO COLLEGE

Above: *Magazine cover, The California Pelican (University of California, Berkeley); art, Steve Ditko and Jack Kirby; November 1965.* While the political turmoil of the day tended to dominate the content of publications on progressive campuses around the country, comics were starting to become part of the thinking student's lexicon. In one of the earliest examples of the growing reach Marvel's characters were having outside the traditional audience, UC Berkeley's student humor magazine embraced Spider-Man and the Hulk, demonstrating that comics weren't just for kids anymore.

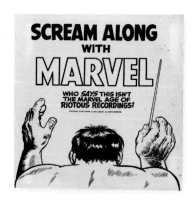

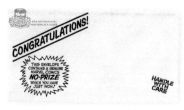

MARVELMANIA REDUX

Above left: *Flexi-disc record; Scream Along with Marvel; pencils and inks, Marie Severin; 1967.* Hulk's first appearance as the maestro! For the second wave of Marvelmania, the M.M.M.S. membership kit now contained a recording of the opening and closing songs from the *Marvel Super-Heroes* TV show: "Stand a little straighter; walk a little prouder; be an innovator; clap a little louder; grow forever greater; we can show you how; where will you be then? You belong, you belong, you belong, you belong to the Merry Marvel Marching Society!!!"

CONGRATULATIONS!

Above right: *No-Prize, 1960s.* If you caught a mistake in a Marvel comic or your fan letter was published in a comic, you received this wonderful envelope — the Hulk staring menacingly from behind the return address — complete with "no prize" inside. (In other words, it was empty!)

JOURNEY INTO MYSTERY No. 112

Opposite: *Interior, "The Mighty Thor Battles the Incredible Hulk!"; script, Stan Lee; pencils, Jack Kirby; inks, Chic Stone; January 1965.* Akin to kids rooting for their favorite baseball team, this splash page features a group of boys supporting their favorite hero and asking the age-old question, "Who is stronger, Thor or the Hulk?" Stan Lee loved to pit one hero against the other, but rarely was there an injury — or a victor!

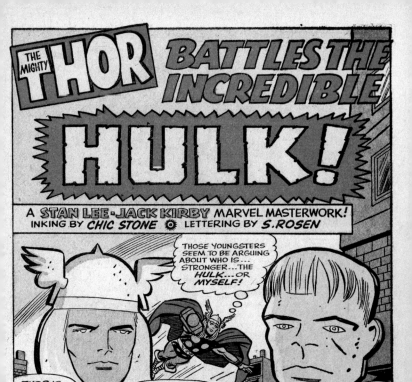

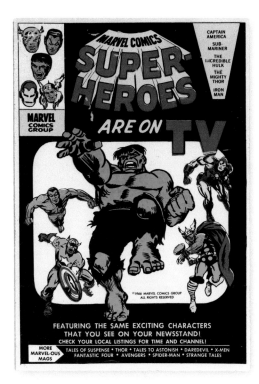

©1966 MARVEL COMICS GROUP
ALL RIGHTS RESERVED

THE HULK IS ON TV!

Opposite: *Animation cel,* Marvel Super-Heroes, *1966.*
Don't get in the Hulk's way, he's got the controls! "[You've] just
got time to make sure your set's in good working order—
check your local paper for time and station—and prepare to
have a ball!"—Stan Lee, announcing the cartoon in the
November 1966 Bullpen Bulletins

DON'T TOUCH THAT DIAL!

Above: *House ad; art, John Romita, Jack Kirby, and Gene Colan;
Grantray-Lawrence Animation; 1966.* In September of 1966 the
Marvel Super-Heroes cartoon was syndicated on television.
Originally shown in early evening hours and featuring a live
host, the simplistic cartoons appeared five nights a week to the
sound of swingin' '60s theme songs, and featured Iron Man,
Captain America, Sub-Mariner, the Hulk, and Thor.

Little Jack Kirby sat in his derby

Drawing the Marble crew...

As he slaved for his wage...

They jumped off the page...

And he said: I THINK THEY MUST'A GOT ME MIXED UP WITH THE OLD WOMAN WHO LIVED IN A SHOE!

NOT BRAND ECHH No. 11

Opposite: *Interior, "Auntie Goose Rhymes Dept."; script, Roy Thomas; pencils and inks, John Verpoorten; December 1968.* The Hulk was one of many characters to spring off the drawing board of Jack Kirby, as lovingly lampooned in this satire from *Not Brand Echh* by Thomas and Verpoorten.

ALL THIS AND A STICK OF GUM!

Above: *Super Hero stickers, 1967.* Donruss may have released the first Marvel trading card set a year earlier, but the Philadelphia Chewing Gum Company was the first to produce a set of Marvel Comics trading cards that were all stickers (55 of them in total). They featured Marvel's most popular super heroes — with three of the 55 devoted to the Hulk — using art from the comic books and adding funny captions. For just a nickel kids could go to the corner drugstore and buy a pack, which consisted of five stickers and a stick of gum.

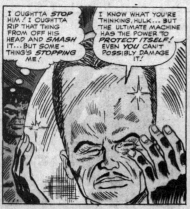

I OUGHTTA *STOP* HIM! I OUGHTTA *RIP* THAT THING FROM OFF HIS HEAD AND *SMASH* IT... BUT SOMETHING'S *STOPPING* ME!

I KNOW WHAT YOU'RE THINKING, HULK... BUT THE ULTIMATE MACHINE HAS THE POWER TO *PROTECT ITSELF!* EVEN YOU CAN'T POSSIBLY DAMAGE IT!

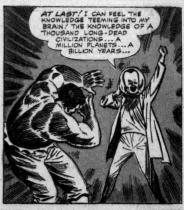

AT LAST! I CAN FEEL THE *KNOWLEDGE* TEEMING INTO MY BRAIN! THE KNOWLEDGE OF A THOUSAND LONG-DEAD CIVILIZATIONS ... A MILLION PLANETS ... A BILLION YEARS...

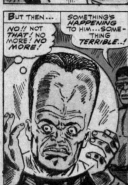

BUT THEN...

NO!! NOT *THAT!* NO MORE! NO MORE!

SOMETHING'S *HAPPENING* TO HIM... SOMETHING *TERRIBLE..!*

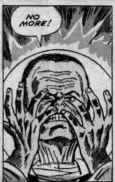

NO MORE!

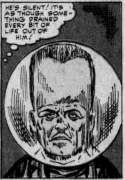

HE'S *SILENT!* IT'S AS THOUGH SOMETHING DRAINED EVERY BIT OF LIFE OUT OF HIM!

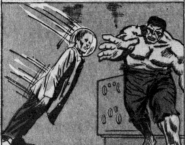

IT HAPPENS SO QUICKLY AS TO STAGGER THE SENSES! ONE MINUTE THE *LEADER* IS SHOUTING IN TRIUMPH... AND THE NEXT, HIS RIGID FORM TOPPLES GROTESQUELY TO THE FLOOR...!

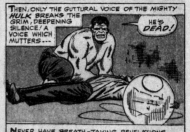

THEN, ONLY THE GUTTURAL VOICE OF THE MIGHTY *HULK* BREAKS THE GRIM, DEEPENING SILENCE! A VOICE WHICH MUTTERS...

HE'S *DEAD!*

NEVER HAVE BREATH-TAKING REVELATIONS COME AS FAST AND FURIOUSLY AS THOSE WHICH AWAIT YOU NEXT ISSUE! WHAT YOU HAVE SEEN BEFORE IS MERELY PRELUDE ...PRELUDE TO A NEW WORLD OF *FANTASY* WHICH IS ABOUT TO OPEN FOR THE HULK! BE HERE TO ENTER IT WITH HIM! 'NUFF SAID!

THE END 10.

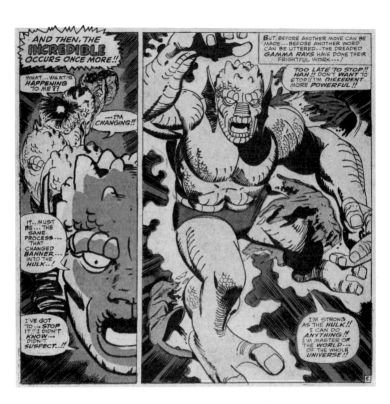

TALES TO ASTONISH No. 74

Opposite: *Interior, "The Wisdom of the Watcher!"; script, Stan Lee; layouts, Jack Kirby; pencils, Bob Powell; inks, Mike Esposito; December 1965.* It turns out the Hulk wasn't the only gamma-irradiated being on Earth. Unlike Bruce Banner, who was a genius turned into a raging brute, lowly janitor Samuel Sterns was turned into one of the greatest brains on the planet — and he had the grotesquely enlarged cranium to prove it!

TALES TO ASTONISH No. 90

Above: *Interior, "The Abomination!"; script, Stan Lee; pencils and inks, Gil Kane; April 1967.* Another gamma monster was the Abomination, a KGB agent named Emil Blonsky who turns a gamma machine on himself and takes a full blast of radiation. The result was as aptly a named character as would come from the Marvel Age of Comics.

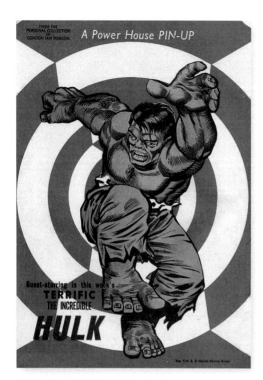

TERRIFIC ADVERTISING

Above: *House ad, Odhams Press, ca. 1968.* British publisher
Odhams Press reprinted Marvel material in black-and-white
weekly comics *Terrific* and *Fantastic*. Each comic came
with a nifty pinup on the rear cover.

THE INCREDIBLE HULK No. 102

Opposite: *Cover; pencils, Marie Severin; inks, Frank Giacoia;
April 1968.* After years of costarring, the Hulk returned to
a full-length comic of his own: In 1968, *Tales to Astonish*
became *The Incredible Hulk*.

THE INCREDIBLE HULK No. 109

Following spread: *Interior, "The Monster and the Man Beast!";
script, Stan Lee; layouts, Frank Giacoia; pencils, Herb Trimpe; inks,
John Severin; November 1968.* The Hulk epitomized every kid's
frustrations of being misunderstood, different, and awkward.
He also offered a cathartic effect: at least he could smash!

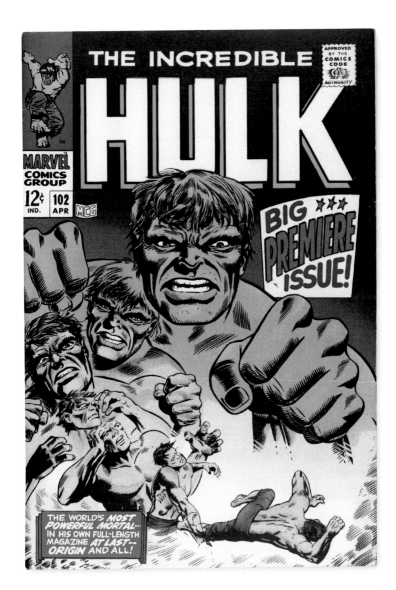

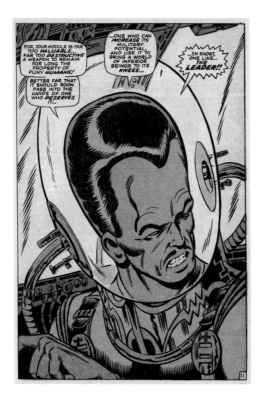

THE INCREDIBLE HULK No. 123

Above: *Interior, "No More the Monster!"; script, Roy Thomas; pencils and inks, Herb Trimpe; January 1970.* The Leader became one of the Hulk's greatest foes, returning frequently to plague the green goliath. Meanwhile, in his 18 months on the book, Herb Trimpe had brought a consistency and excitement to the strip and would wind up making the Hulk his own.

CAPTAIN AMERICA No. 110

Opposite: *Cover; pencils and inks, Jim Steranko; February 1969.* Captain America and Bucky have their work cut out for them when facing off against Steranko's raging, bug-eyed Hulk.

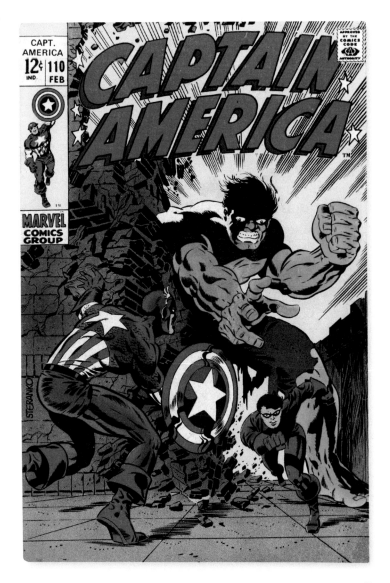

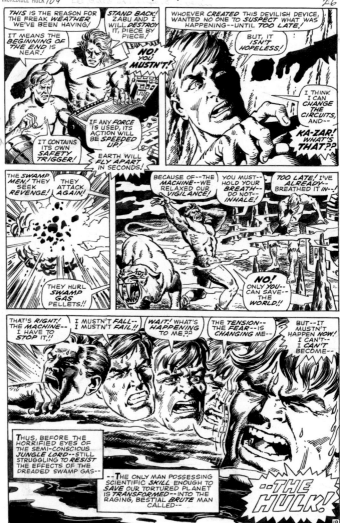

THIS is the reason for the FREAK WEATHER WE'VE been having!

IT MEANS the BEGINNING OF THE END IS NEAR!

STAND BACK! ZABU AND I will DESTROY it, piece by piece!

NO! YOU MUSTN'T!

IF any FORCE is used, its action will be SPEEDED UP! EARTH will FLY APART in seconds!

IT contains ITS OWN SAFETY TRIGGER!

WHOEVER CREATED this DEVILISH DEVICE, wanted NO ONE to SUSPECT what was HAPPENING--until TOO LATE!

BUT, IT ISN'T HOPELESS!

I THINK I CAN CHANGE the CIRCUITS, AND--

KA-ZAR! WHAT'S THAT??

THE SWAMP MEN! THEY SEEK REVENGE!

THEY ATTACK AGAIN!

THEY HURL SWAMP GAS PELLETS!!

BECAUSE OF--THE MACHINE--WE RELAXED OUR VIGILANCE!

YOU MUST-- HOLD YOUR BREATH-- DO NOT-- INHALE!

TOO LATE! I'VE ALREADY-- BREATHED IT IN--

NO! ONLY YOU-- CAN SAVE-- THE WORLD!!

THAT'S RIGHT! THE MACHINE-- I HAVE to STOP IT!!

I MUSTN'T FALL-- I MUSTN'T FAIL!!

WAIT! WHAT'S HAPPENING TO ME??

THE TENSION-- THE FEAR--IS CHANGING ME--

BUT--IT MUSTN'T HAPPEN NOW! I CAN'T-- I CAN'T BECOME--

THUS, BEFORE THE HORRIFIED EYES OF THE SEMI-CONSCIOUS JUNGLE LORD--STILL STRUGGLING to RESIST THE EFFECTS OF THE DREADED SWAMP GAS--

--THE ONLY MAN POSSESSING SCIENTIFIC SKILL ENOUGH to SAVE OUR TORTURED PLANET IS TRANSFORMED--INTO THE RAGING, BESTIAL BRUTE MAN CALLED--

--THE HULK!

19

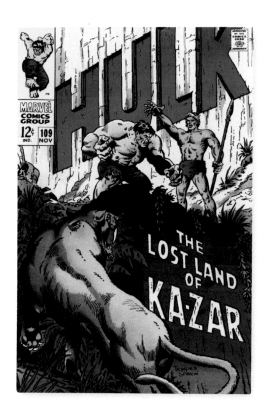

THE INCREDIBLE HULK No. 109

Opposite: *Original art; pencils, Herb Trimpe; inks, John Severin; November 1968.* The intellect of Bruce Banner is needed to save the world from destruction, with guest-star Ka-Zar at his side. But can Banner complete his mission before he turns into his brutish alter ego?

THE INCREDIBLE HULK No. 109

Above: *Interior, "The Monster and the Man-Beast!"; script, Stan Lee; layouts, Frank Giacoia; pencils, Herb Trimpe; inks, John Severin; November 1968.* Banner's genius is poised to save the day — but there's only one problem: Here comes the Hulk!

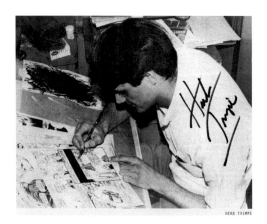

HERB TRIMPE

WE LOVE YOU HERB TRIMPE

Above: *Photograph, Robert Policastro; Herb Trimpe; early 1970s.*
Trimpe was a production artist before getting his shot at
penciling full-time. A 1970 NYU student film documenting
the Marvel bullpen with the above title betrays the import
of the humble Bullpenners — Trimpe in particular was
teased by his fellows as a bit of a heartthrob.

ON THE COVER OF ROLLING STONE

Opposite: *Magazine cover,* Rolling Stone *No. 91; pencils and inks,
Herb Trimpe; September 16, 1971.*

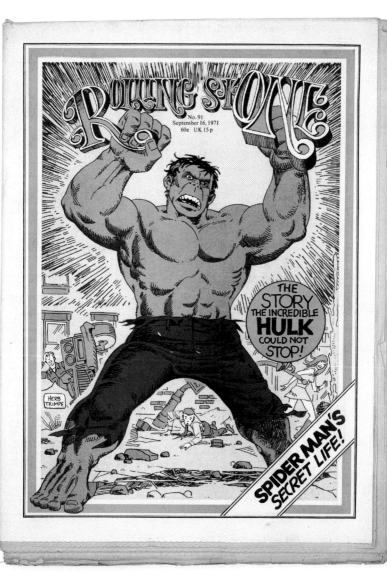

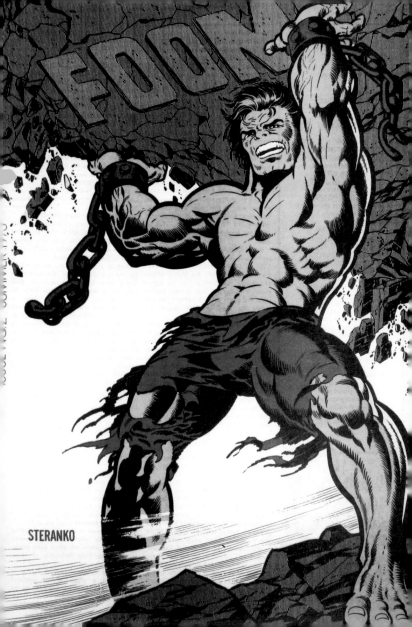

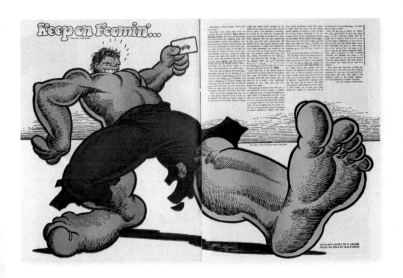

F. O. O. M. No. 2

Opposite and above: *Cover and interior, Jim Steranko, Summer 1973.* Jim Steranko started an in-house Marvel fanzine in 1973, with the Hulk (by the new editor and still-hot artist) covering the series' second issue. The growing influence of underground comix on Marvel creators was made incredibly clear in this issue. Inside, Steranko paid homage "with apologies" to Robert Crumb's "Keep on Truckin'." (Those apologies may have been appreciated by the inspirational indie, who wrote: "[Truckin'] is the curse of my life. This stupid little cartoon caught on hugely."

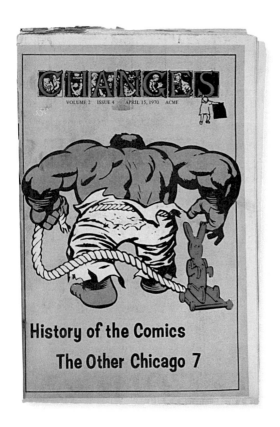

CHANGES Vol. 2, No. 4
Above: *Cover; artist unknown; April 15, 1970.*

FANTASTIC FOUR No. 112
Opposite: *Cover; pencils, John Buscema; inks, Frank Giacoia;
July 1971.* Thing vs. the Hulk: The gift that kept on giving!
This time around, it was the Thing having a berserker rage
through New York City, with Bruce Banner getting caught
in the mayhem and — you guessed it! — changing into the
Hulk to settle matters.

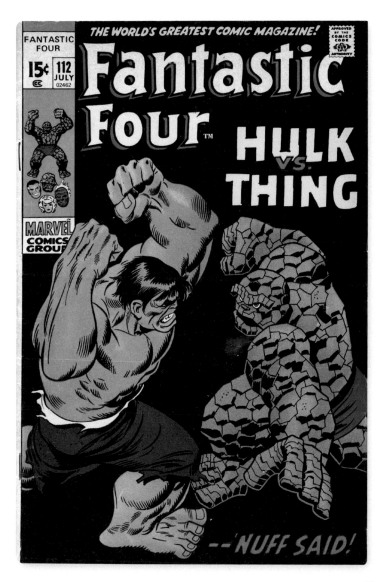

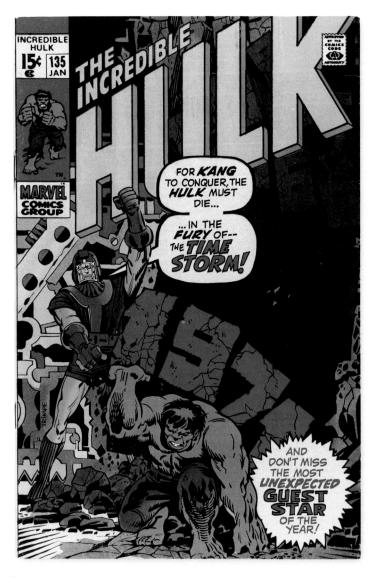

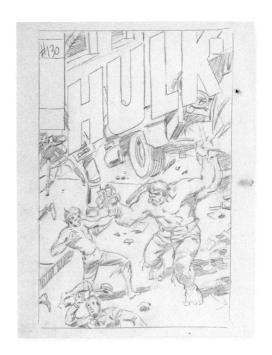

THE INCREDIBLE HULK No. 135

Opposite: *Cover: pencils and inks, Herb Trimpe; January 1971.*
Kang's time-traveling threat was translated into a novel
cover design as the years came literally crashing down over
the Hulk. But for Trimpe, his tenure drawing the *Incredible
Hulk* was very kind, as his seven-year run coincided with
the rise of Hulk's immense popularity, setting the stage for
the long-running TV show, magazine, and cartoons, all
cementing Trimpe as one of the Hulk's all-time great artists.

THE INCREDIBLE HULK No. 130

Above: *Cover sketch; pencils, Herb Trimpe; ca. 1970.* Trimpe
sketches out a layout idea. The final cover would pull in closer
to the action, placing the Hulk vs. Banner confrontation
more in the foreground.

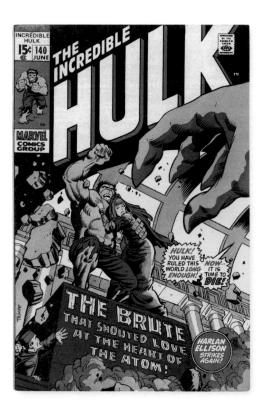

THE INCREDIBLE HULK No. 140

This spread: *Cover; pencils and inks, Herb Trimpe. Interior,*
"The Brute That Shouted Love at the Heart of the Atom"; plot,
Harlan Ellison; script, Roy Thomas; layouts, Herb Trimpe; pencils
and inks, Sam Grainger. June 1971. Harlan Ellison gets a cover
blurb! This unusual editorial move was emblematic of an
Ellison fan who couldn't help himself, namely scripter Roy
Thomas, who also took it upon himself to bury the names of
20—count 'em!—20 Ellison stories in the issue's dialogue.
Finishing up a story begun in *Avengers* No. 88, this story intro-
duces the lovely Princess Jarella, whose subatomic kingdom
is rescued by the Hulk. A romance ensues—a first for the
Hulk—but as in all things Marvel, it is fated for tragedy…a
mere few years down the road.

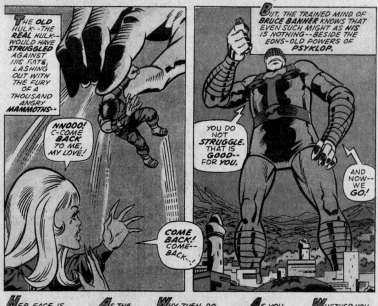

THE OLD HULK--THE REAL HULK--WOULD HAVE STRUGGLED AGAINST HIS FATE, LASHING OUT WITH THE FURY OF A THOUSAND ANGRY MAMMOTHS--

NNOOO! C-COME BACK TO ME, MY LOVE!

COME! BACK! COME-- BACK--!

BUT, THE TRAINED MIND OF BRUCE BANNER KNOWS THAT EVEN SUCH MIGHT AS HIS IS NOTHING--BESIDE THE EONS-OLD POWERS OF PSYKLOP.

YOU DO NOT STRUGGLE. THAT IS GOOD--FOR YOU.

AND NOW-- WE GO!

HER FACE IS RECEDING NOW... SOON TO BE LOST IN DARKNESS AND IN DISTANCE...

...AS THE ELDRITCH HORROR THAT IS PSYKLOP BEGINS TO GROW... GROW...!

WHY, THEN, DO YOU SEE HER EVER MORE CLEARLY, HULK? WHAT MAKES YOU WONDER...

...AS YOU ESCALATE, GRAVITATE THRU UNIVERSES BLACK ON BLACK, WHITE ON WHITE,...

...WHETHER YOU MIGHT NOT LIKEWISE EXIST IN THE TEAR-DROP COSMOS THAT MISTS THE EYE OF FAIR JARELLA....?

18

CONTINUED AFTER NEXT PAGE

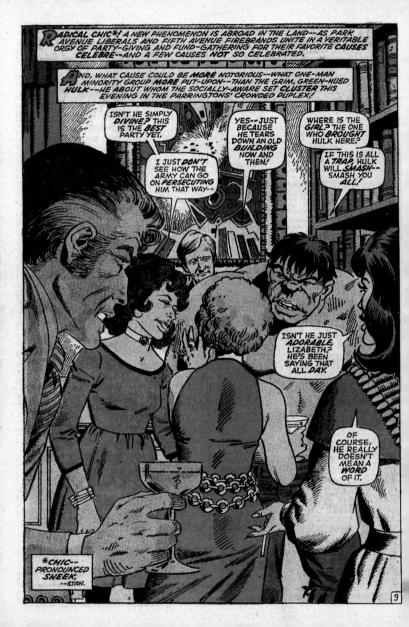

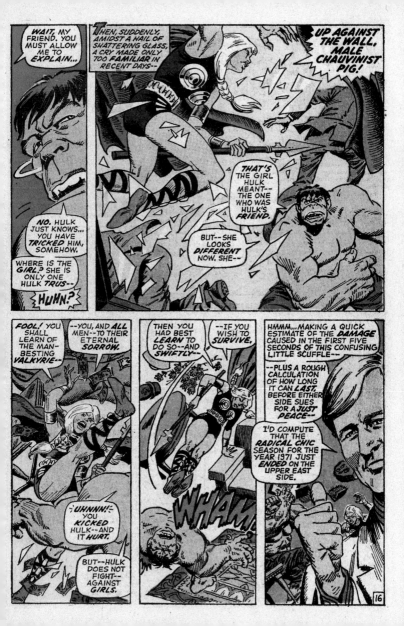

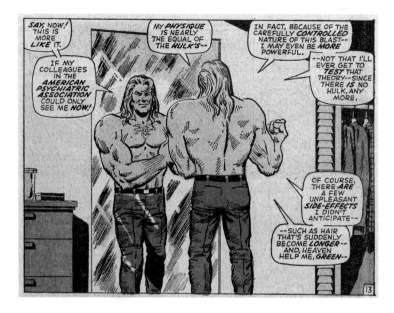

THE INCREDIBLE HULK No. 142

Previous spread: *Interiors, "They Shoot Hulks, Don't They?";* *script, Roy Thomas; pencils, Herb Trimpe; inks, John Severin; August 1971.* Roy Thomas brings in author and social critic Tom Wolfe for a cameo to gently rib Manhattan high society's liberal impulses and the women's liberation movement, his script having found inspiration in Wolfe's 1970 book of essays *Radical Chic & Mau-Mauing the Flak Catchers.* Heady stuff for the Hulk!

THE INCREDIBLE HULK No. 141

Above: *Interior, "His Name Is . . . Samson!"; script, Roy Thomas; pencils, Herb Trimpe; inks, John Severin; July 1971.* Some gamma radiation victims, like Bruce Banner, are cursed with a monstrous alter ego that ruins their life. Others, like Doctor Leonard Samson, gain super-strength and glorious green locks. The super-powered psychologist would remain a supporting cast member of the *Incredible Hulk* series long after this, his first appearance.

THE INCREDIBLE HULK No. 141

Opposite: *Cover; pencils and inks, Herb Trimpe; July 1971.*

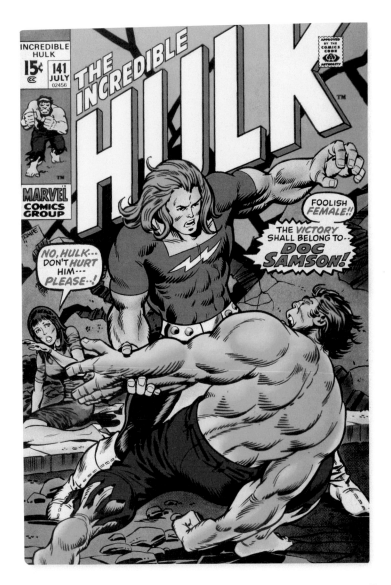

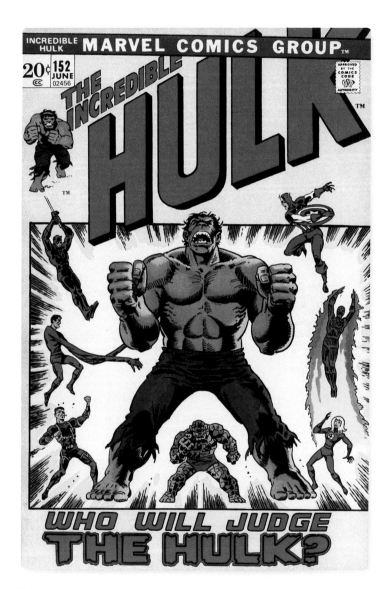

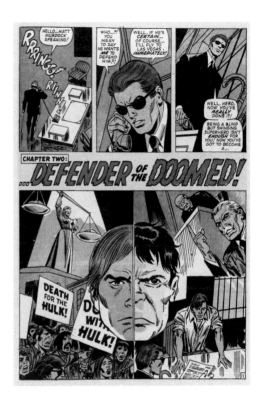

THE INCREDIBLE HULK No. 152

Opposite: *Cover; pencils, Herb Trimpe; inks, John Severin; June 1972.* The Hulk goes to court, or at least, Bruce Banner does! It was bound to happen after all the destruction left behind in the Hulk's wake.

THE HULK GETS THE DEATH PENALTY?

Above: *Interior, "But Who Will Judge the Hulk?"; script, Gary Friedrich; pencils, Dick Ayers and Herb Trimpe; inks, Frank Giacoia and the Marvel Bullpen; June 1972.* Well, we know who will defend the Hulk: Matt Murdock, better known as Daredevil. The blind attorney with the red tights and devil horns has to talk his suicidal client, Bruce Banner, out of pleading guilty and demanding the electric chair.

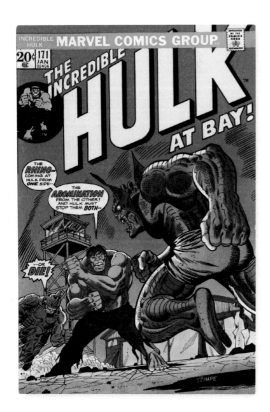

THE INCREDIBLE HULK No. 171

Above: *Cover; pencils and inks, Herb Trimpe; January 1974.*
Writer Steve Englehart ended a 13-issue run by sticking the
Hulk in the middle of a Rhino–Abomination sandwich.

THE INCREDIBLE HULK No. 144

Opposite: *Interior, "The Monster and the Madman!"; script,*
Gary Friedrich and Roy Thomas; pencils, Dick Ayers; inks, John
Severin; October 1971. Doctor Doom kidnaps Bruce Banner
and forces him into labor designing weapons for him. It works
well for about 10 pages of story but even Doom can't plan for a
contingency like the Hulk!

PLEASE! DON'T START AGAIN!

DO NOT WORRY! THE FIGHT--IS OVER!

NO! IT IS NOT ENDED --WHILE YOU STILL LIVE!

OH, VICTOR...I WAS SO FRIGHTENED! I WAS AFRAID HE'D KILL YOU! ARE YOU ALL RIGHT?!

I CAN NEVER BE ALL RIGHT--NEVER REST--TILL THE BATTLE IS DECIDED!

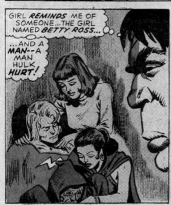

GIRL REMINDS ME OF SOMEONE...THE GIRL NAMED BETTY ROSS...

...AND A MAN--A MAN HULK HURT!

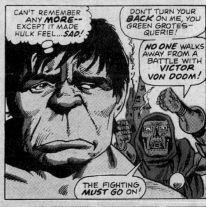

CAN'T REMEMBER ANY MORE-- EXCEPT IT MADE HULK FEEL...SAD!

DON'T TURN YOUR BACK ON ME, YOU GREEN GROTES-QUERIE!

NO ONE WALKS AWAY FROM A BATTLE WITH VICTOR VON DOOM!

THE FIGHTING MUST GO ON!

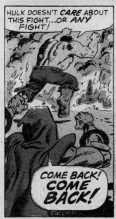

HULK DOESN'T CARE ABOUT THIS FIGHT...OR ANY FIGHT!

COME BACK! COME BACK!

ALL HULK WANTS...

...IS TO BE FAR AWAY...

...AND ALL ALONE!

-FINIS-

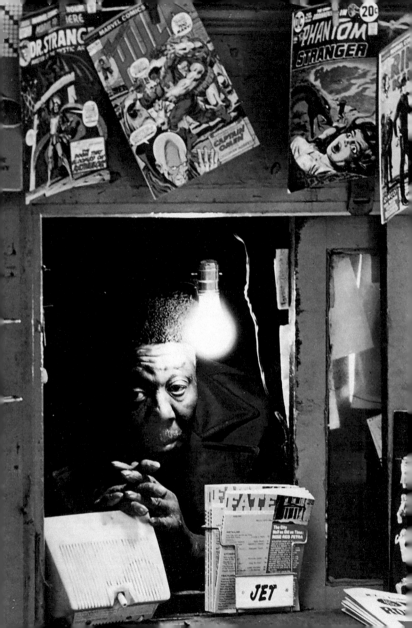

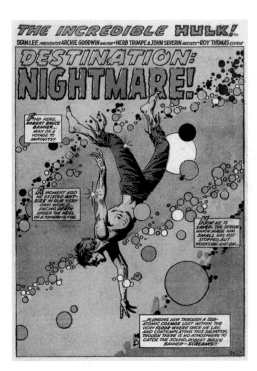

HULK FOR SALE!
Opposite: *Photograph, 1973.* A sidewalk newsstand has a Hulk comic pinned to a string.

THE INCREDIBLE HULK No. 155
Above: *Interior, "Destination: Nightmare!"; script, Archie Goodwin; pencils, Herb Trimpe; inks, John Severin; September 1972.* One of the fun recurring storylines for the series featured the Hulk shrinking down to size for adventures in microscopic worlds.

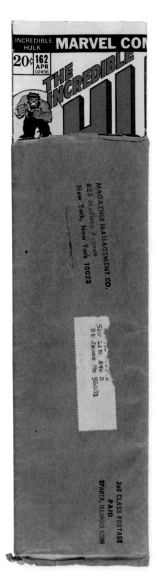

MAILED NOT-SO-FLAT!

Left: *Subscription envelope,* The Incredible Hulk *No.162, April 1973.* Comics from the early years of subscription circulation are easily distinguished by the irrevocable crease down the middle from their journey through the U.S. postal system. Later subscription ads declared all books would be "MAILED FLAT!," no doubt to assuage discouraged subscribers with an eye on condition.

MARVEL FEATURE No. 1

Opposite: *Cover; pencils and inks, Neal Adams; December 1971.* Spinning out of story threads sewn in Roy Thomas–scribed issues of *Sub-Mariner, Dr. Strange,* and *Incredible Hulk* came Marvel's first post-Avengers assembling of solo heroes, proudly described as the world's greatest "non-team," the Defenders!

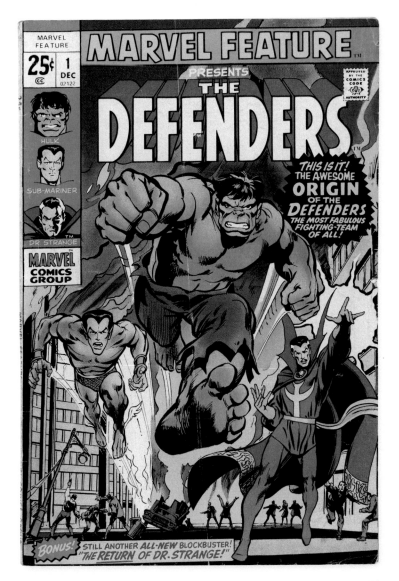

MARVEL FEATURE No. 1

Above: *Interior, "The Day of the Defenders!"; script, Roy Thomas; pencils, Ross Andru; inks, Bill Everett; December 1971.* Just like in the Avengers, bickering between heroes seemed a story-telling mandate—even more so when the Hulk would become part of the Defenders.

GIANT-SIZE DEFENDERS No. 1

Opposite: *Original cover art; pencils, Gil Kane; inks, Frank Giacoia; July 1974.* Though the prolific Gil Kane rarely drew the Hulk in his own title, he penciled several *Defenders* covers during its run, including a snarling Hulk leaping out of the cover art to the first *Giant-Size* issue.

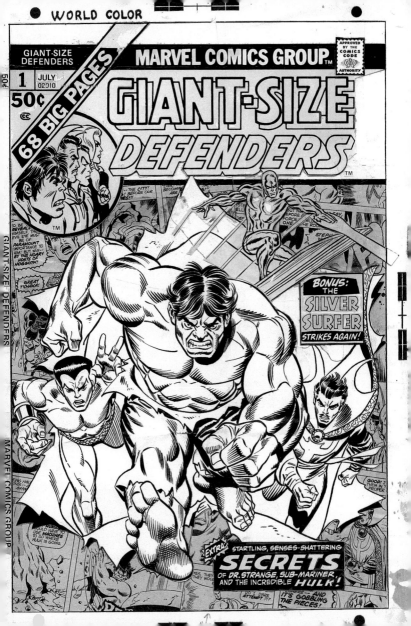

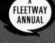

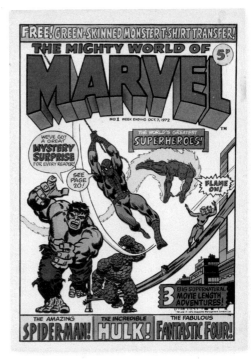

MARVEL ANNUAL 1973
Opposite: *Cover, artist unknown, 1973*. In the UK, there's a
proud tradition of collecting comic book strips in hardcover
"annuals"—a staple under every child's Christmas tree.
Publisher Fleetway reprinted Marvel Comics in this way for
many years, initially titled as the *Marvel Annual*. And, proving
that British kids thought the Hulk was "smashing," four of
those *Marvel Annuals* featured the Jade Goliath on the cover.

MIGHTY WORLD OF MARVEL No. 1
Above: *Cover; pencils, John Buscema; inks, Frank Giacoia;
October 1972.* "*The Dandy* and *The Beano* were simply comics;
Marvel was a universe," wrote Geoff Dyer. "The more deeply
you got into them, the more encompassing Marvel comics
became: characters from one title would guest in another...so
that each magazine offered a different glimpse of—and take
on—a world that was imaginatively complete."

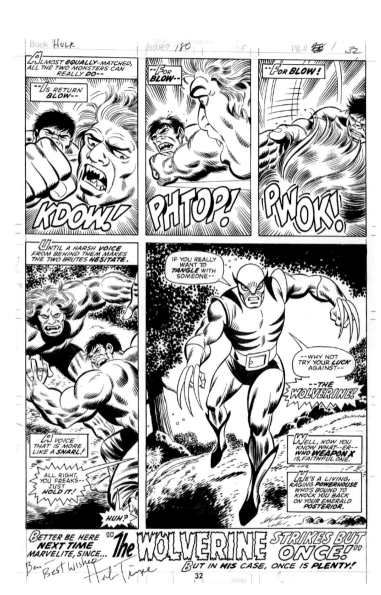

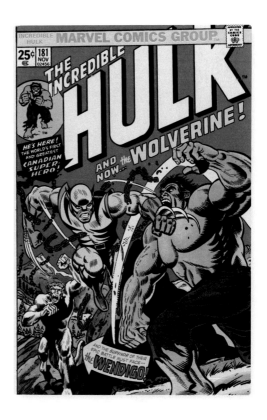

THE WOLVERINE STRIKES BUT ONCE!

Opposite: *Original art,* The Incredible Hulk *No. 180; script, Len Wein; pencils, Herb Trimpe; inks, Jack Abel; October 1974.* Wolverine interrupts a Hulk vs. Wendigo slobberknocker on the final page of his true first appearance. Given as a souvenir by Trimpe to a teenage fan in 1983, this page resurfaced in 2014 and sold at auction, tying the world record for a page of comic art at $657,250!

THE INCREDIBLE HULK No. 181

Above: *Cover; pencils and inks, Herb Trimpe; November 1974.* "And Now…the Wolverine!," the figure who would become central to comics' new direction.

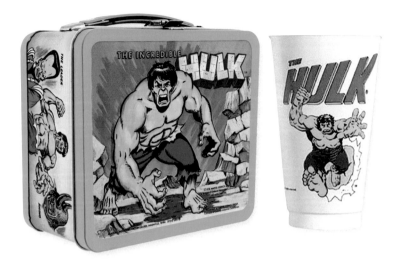

HULK WANT BEANS FOR LUNCH!

Above left: *Lunchbox; art, attributed Sal Buscema; 1978.*
Lunchbox manufacturer Aladdin scored a hit in the
late '70s with its Hulk lunchbox, complete with Hulk-
emblazoned thermos.

OH, THANK HEAVEN . . .

Above right: *Marvel 7-Eleven Slurpee cup, 1975.* For a time,
you could get your favorite frozen flavored drink in a
5.25-inch-tall plastic cup featuring a dizzying array of Marvel
characters. And out of all sixty cups available, there was
nothing like scoring a Wild Cherry Slurpee in a cup with the
green-skinned, purple-pantsed Incredible Hulk on the side.

LEGGO MY MEGO!

Opposite: *Mego World's Greatest Super Heroes Incredible Hulk
action figure, 1979.* Toy manufacturer Mego's World's Greatest
Super Heroes line mixed a growing number of Marvel and
DC characters in the 1970s, allowing fans to realize all their
crossover dreams. The Hulk finally joined the roster in 1974.
Though a slow seller at first, the popularity of the *Incredible
Hulk* TV series established him as one of Mego's "Big Four"
(along with Spider-Man, Batman, and Superman) by the time
of this figure's release in 1979.

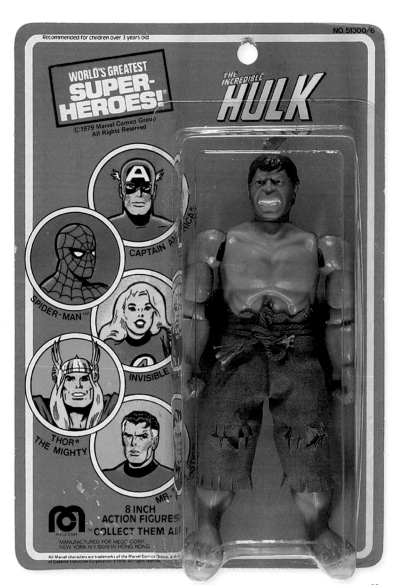

83

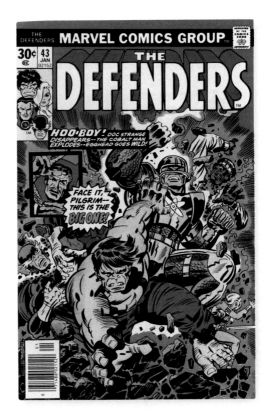

GIANT-SIZE DEFENDERS No. 1
Opposite: *Interior, "The Way They Were!"; script, Tony Isabella; pencils, Jim Starlin; inks, Al Milgrom; July 1974.*

DEFENDERS No. 43
Above: *Cover; pencils, Jack Kirby; inks, Al Milgrom; January 1977.* Jack "The King" Kirby had returned to Marvel in 1975, and was able to once again draw some of his fabled cocreations on various covers well into the late '70s.

DEFENDERS No. 50
Following spread: *Interior, "Who Remembers Scorpio Part Three: Scorpio Must Die!"; script, David Anthony Kraft; pencils and inks, Keith Giffen; August 1977.*

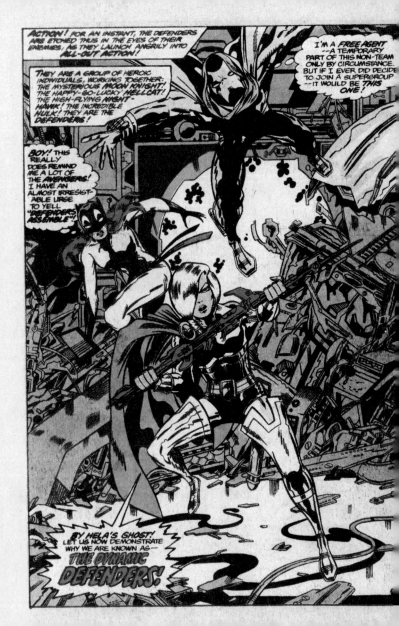

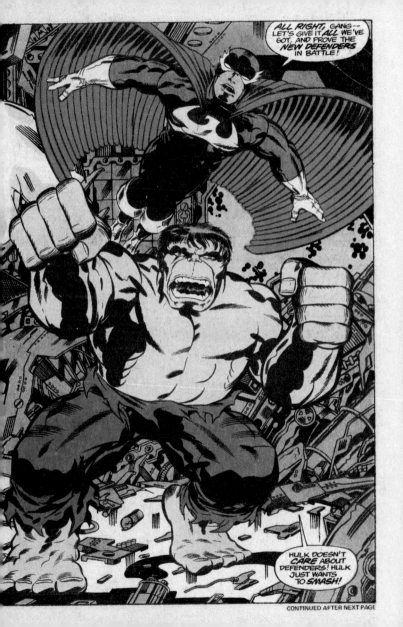

CONTINUED AFTER NEXT PAGE

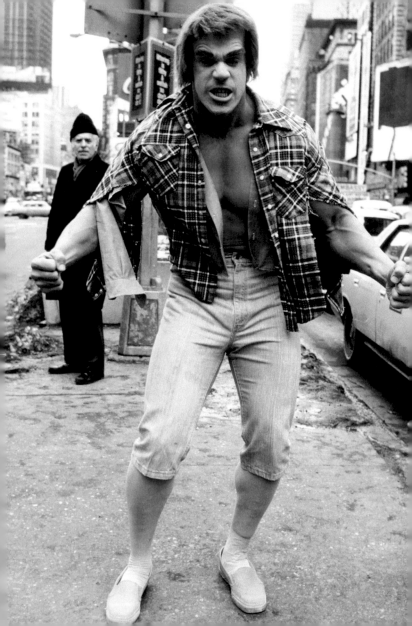

LOU FERRIGNO IS . . . THE HULK!

Opposite: *Photo, ca. 1980.* Lou Ferrigno poses as the Hulk in a publicity photo for the pre-CGI TV series *The Incredible Hulk.* Ferrigno beat out Richard Kiel, the James Bond villain known as Jaws, who was deemed not muscular enough; and Arnold Schwarzenegger, deemed not tall enough.

A VIDEO NOVEL

Below: *Interior;* Stan Lee Presents the Incredible Hulk, a Video Novel; *script adaptation, Roy Thomas; original screenplay, Kenneth Johnson; Pocket Books; 1979.* In the days before home video and ubiquitous reruns, the mass market paperback "video novel" was a great way for young readers to relive the exciting moments of pop culture sensations like the *Incredible Hulk* TV show. For this title, Roy Thomas adapted Kenneth Johnson's screenplay and also selected all the screencaps used in the narrative.

—is different!

One moment, on waking, he is *David Banner*— the same as ever, save for those strangely *white eyes,* with ever the slightest hint of *green*—

98

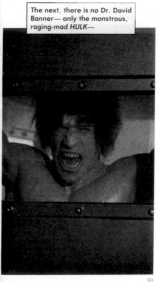

The next, there is *no* Dr. David Banner— only the monstrous, raging-mad *HULK*—

99

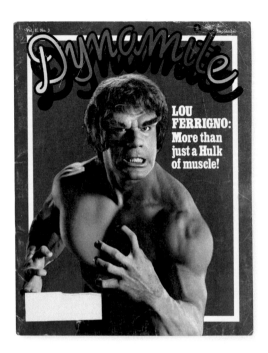

Vol. II. No. 3 — September

DON'T MAKE ME ANGRY...

Above: *Magazine cover*, Dynamite, *1978*. Filmed for CBS on the backlot of Universal Studios, *The Incredible Hulk* series ran for 82 one-hour episodes with Bill Bixby as scientist David Banner (a departure from Bruce Banner, his name in the comics) and body-builder Lou Ferrigno as his growling, green alter ego. The forlorn theme music and the internalized performance of television veteran Bixby make the show a melancholy science-fiction version of *The Fugitive* with far less wink than even Richard Donner's *Superman*.

CRAZY No. 42

Opposite: *Cover art; art, Bob Larkin; September 1978*. Bob Larkin's painted cover for the humor magazine *Crazy* shows off the goofy side of Marvel's two flagship characters. The enormous success of his TV show gave the Hulk equal footing with Spidey in the overall pop culture landscape for the first time.

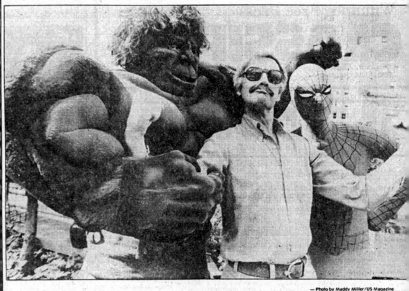

— Photo by Maddy Miller/US Magazine

Stan Lee, the man who dreamed up The Incredible Hulk and Spider Man, stands with recreations of his dreams.

Creator of Spider-Man and The Hulk could win race against Capt. America

By RICHARD ZOGLIN

Unlike the bizarre characters who populate his comic books, Stan Lee can't fly through the air, scale a sheer wall (without a ladder) or burst into flames at will. The man who dreamed up The Incredible Hulk, Spider-Man, The Human Torch and the rest of Marvel Comics' fantastic superheroes is very much an ordinary mortal.

In his work, however, Lee's powers do seem to border on the superhuman. As publisher and creative wizard of Marvel, the largest comic book company in the United States, 55-year-old Lee moves at a pace that would make even Captain America pause for breath.

"I love being busy. I work 24-hour days," says Lee, pacing around his comic book-lined Manhattan office.

Much of Lee's energy is now channelled into his duties as script consultant for television versions of The Incredible Hulk (for Universal Studios) and The Amazing Spider-man (for Chuck Fries Product-

ions), as well as for 11 other Marvel characters in various stages of development at Universal. He views both TV series with pride and dismay.

"The producers made a lot of changes that I didn't think were right," he says. "The Hulk is good, but it could be great. They take plots that are pretty much like those of any other TV show and just put the Hulk into them. We have a much closer relationship now, but they thought the character was too comic book-y, so they took conventional plots people would feel more comfortable with.

"The big problem — I think I've finally convinced the producers of this — is that Peter Parker (Spider-Man's alter ego) is too much of a Henry Aldrich type. The show needs less 'gosh' and 'wow' and more maturity." (CBS, too, found Spider-Man wanting. After a strong start, the series dropped in ratings and has not won a place on the fall schedule. However, CBS ordered at least eight more episodes, most

likely as specials.)

Despite his aggressively outgoing exterior, the comic king thinks of himself as "rather shy" — a description that happens to fit Spider-Man's Peter Parker. Unlike boringly well-adjusted Clark Kent, and unlike Superman, whose heroism wins huzzahs, Spider-Man is burdened with a public that misconstrues his feats as the work of a selfish glory-seeker. The creation of such feet-of-clay superheroes as Spider-Man and the Fantastic Four, who bicker constantly among themselves, is Lee's contribution to the genre.

When Lee went to work for Timely Comics in 1939, he changed his name from Stanley Martin Lieber. "I was saving that for the Great American Novel," he says. The novel didn't come but editorship of the company did — Lee's bosses left the company within a few months. The name changed several times, lastly in the early '60s, when

Lee named it Marvel. ("We ne[ed] something with more sex appe[al].")

For years Lee wrote all of [Mar]vel's comics. Now, with an a[nnual] income estimated at $150,00[0, he] writes less and works at diver[sify]ing Marvel into paperbacks, [chil]dren's humor comics and sp[ecial] features such as its comic [book] history of the Beatles. That, p[lus] 40 lectures a year at coll[eges,] leaves him little time for his [per]sonal life, which he devotes a[lmost] totally to wife Joan, an ex-a[ctress] to whom he's been marri[ed 30] years, and their 25-year-old d[augh]ter, a sometime singer and ac[tress] also named Joan. Parents [and] daughter live blocks apart on [Man]hattan's East Side. They often [meet] for dinner in a neighborhoo[d res]taurant and on weekends gath[er at] Lee's house on Long Island. [Even] there, he spends most of his t[ime] working. "I guess you could c[all me] a workaholic," he says, then [says] "but it isn't work, it's fun."

US magazine

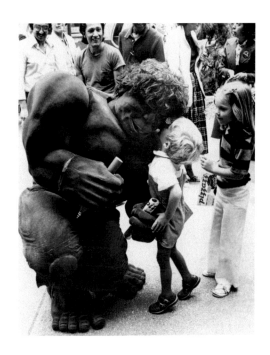

STAN, HULK, SPIDEY, AND CBS
Opposite: *Newspaper article*, Winnipeg Free Press, *July 14, 1975*. An article in Canada's *Winnipeg Free Press* catches Stan Lee in the early days of Marvel TV development, describing the pitfalls of adapting comic book properties like Spider-Man (already off the CBS schedule) and Hulk (fast becoming a hit).

THE LIGHTER SIDE OF THE HULK
Above: *Photograph, ca. 1978*. A child kisses the Hulk at a Marvel mall meetup.

THE HULK! No. 10
Following spread: *Original cover art, Val Mayerik; August 1978*. The magazine that had been *The Rampaging Hulk* was reworked in full-color as *The Hulk!* with No. 10 to capitalize on the success of the television series.

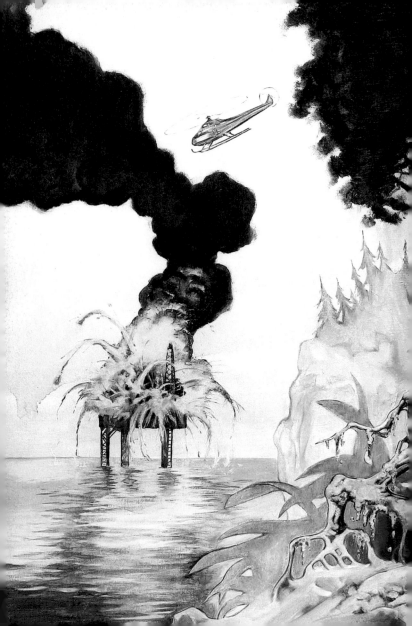

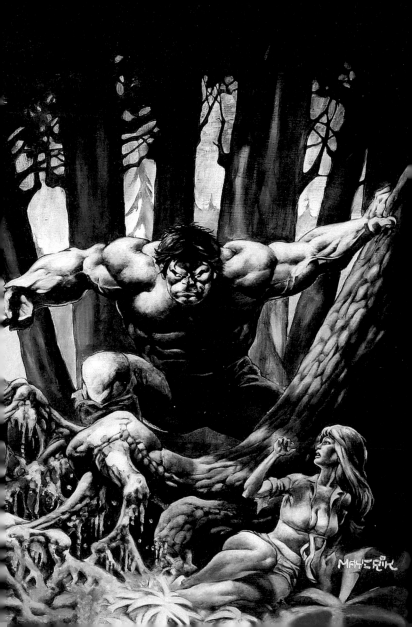

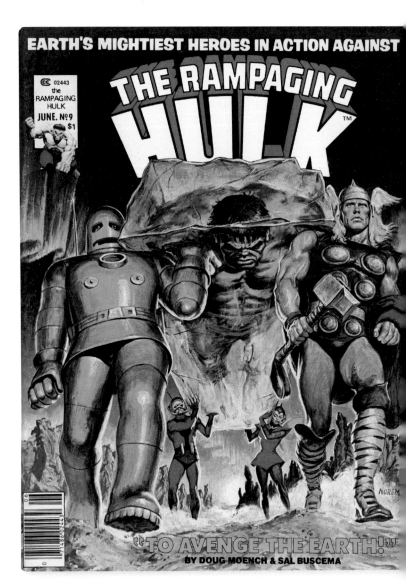

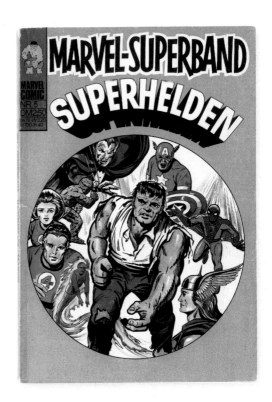

RAMPAGING HULK No. 9
Opposite: *Cover; art, Earl Norem; June 1978.*

MARVEL-SUPERBAND SUPERHELDEN No. 5
Above: *Cover; clip art, various; ca. 1975.* Publisher Williams Verlag issued German translations of Marvel fare in *Marvel-Superband Superhelden,* including vintage Hulk stories.

INCREDIBLE HULK COMIC STRIP
Following spread: *Comic strip; script, Stan Lee; pencils, Larry Lieber; inks, Frank Springer; January 21, 1979.* The Hulk's innate goodness comes out in this strip by Stan Lee and Larry Lieber. The strip was grounded in the ethos of the hit television show, with "David" Banner's likeness approximating that of series star Bill Bixby.

THE INCREDIBLE HULK

STAN LEE & LARRY LIEBER

THE GAS JETS ARE ON-- AND LILA'S INSIDE!

LILA! LILA! CAN YOU HEAR ME?

SHE CAN'T LAST MUCH LONGER! I'VE GOT TO GET IN!

STAN & LARRY LEE LIEBER 1/2!

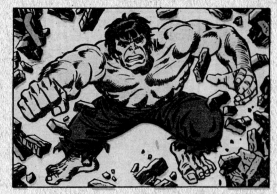

I'VE-- GOT-- TO!

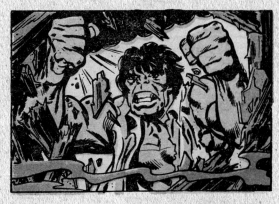

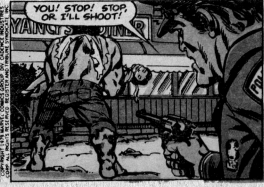

YOU! STOP! STOP, OR I'LL SHOOT!

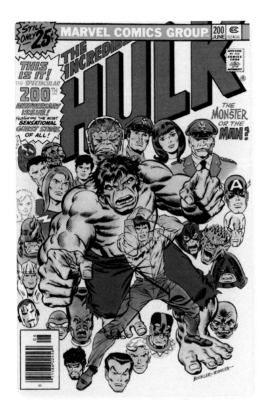

THE INCREDIBLE HULK No. 200

Above: *Cover; pencils, Rich Buckler; inks, John Romita; June 1976.* The Hulk is shrunk to microscopic size to journey into the brain of Glenn Talbot. Hulk helps restore Talbot's memories, and finds himself cast off into a strange and dangerous world.

THE INCREDIBLE HULK No. 239

Opposite: *Cover; pencils and inks, Al Milgrom; September 1979.* In a two-year stretch from September 1978 to September 1980, *Incredible Hulk* comics began carrying a "Marvel's TV Sensation" slogan on the cover.

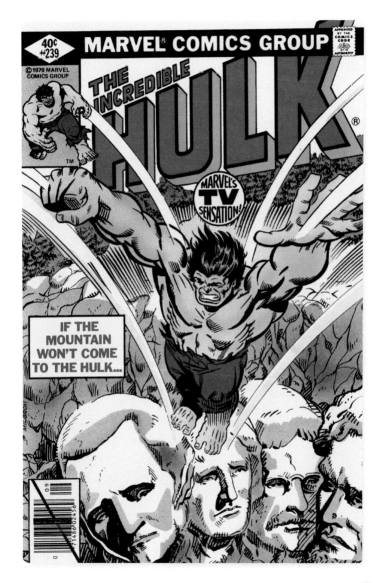

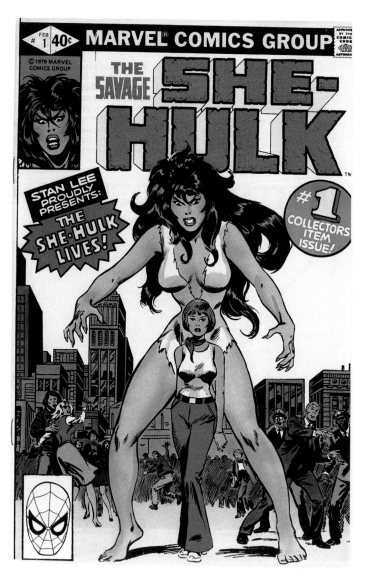

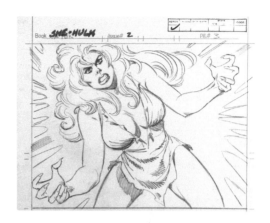

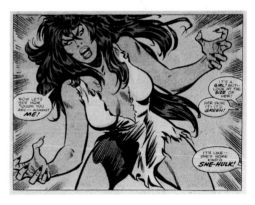

SAVAGE SHE-HULK No. 1

Opposite: *Cover; pencils and inks, John Buscema; February 1980.*
Fearing Universal might create a female Hulk to complement
its hit television series—thus complicating ownership of such
a Hulk-related property between Universal and Marvel—Stan
Lee preemptively developed a "She-Hulk" for Marvel Comics.

SHE-HULK No. 1

Above: *Interior layout pencils and final art, "The She-Hulk
Lives"; script, Stan Lee; pencils, John Buscema; inks, Chic Stone;
February 1980.*

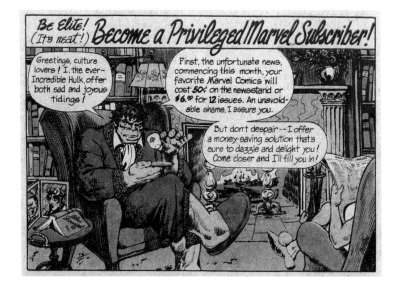

SUBSCRIBE OR ELSE . . . HULK SMASH??

Above: *Subscription advertisement, artist unknown, ca. 1980.*
Marvel used a "sophisticated" Hulk to shill subscriptions in
this 1980 advert. It also used him to break the news about
comic book price hikes (savvy move, Marvel!). And is that She-
Hulk lounging in the library with her cousin?

MARVEL SUPER-HEROES No. 102

Opposite: *Pinup, "My Hulk, My Love!"; script, Roger Stern;
pencils, Herb Trimpe; inks, Jack Abel; October 1981.* In the last
year of its run before cancellation, Marvel began augmenting
its Hulk reprint title *Marvel Super-Heroes* with newly drawn
parody pinups of the Hulk in a variety of styles, such as
Western hero, a Star Wars character, or as the love interest in
a romance novel.

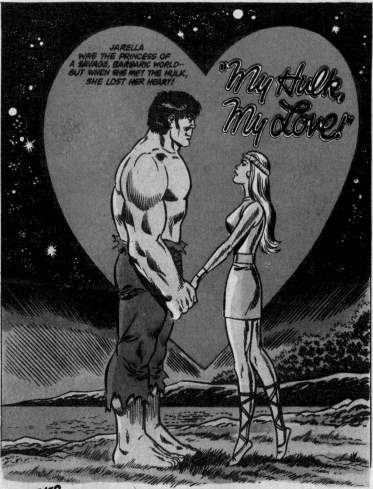

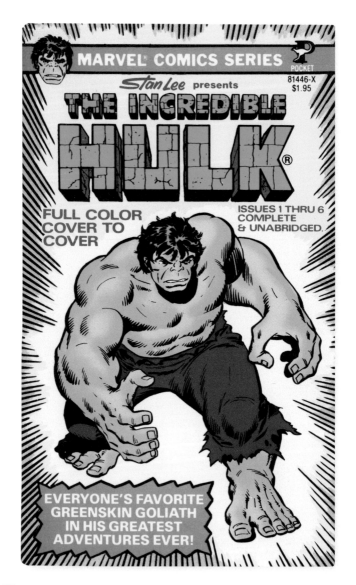

POCKET-SIZED HULK

Opposite: *Cover; pencils and inks, Sal Buscema; 1978.* New York publisher Pocket Books reprinted the first six issues of *The Incredible Hulk* by Stan Lee, Jack Kirby, and Steve Ditko, in mass market paperback.

ANIMATED HULK

Above: *Animation cel,* The Incredible Hulk, *Marvel Productions, 1982.* Saturday mornings got a lot greener in the animated series starring the Hulk, which was narrated by Stan Lee and hewed much closer to the comic book series than the well-known live-action TV series.

POP-UP HULK

Below: *Interior, artist unknown, 1980. The Incredible Hulk: "Trapped!"* was a pop-up book by UK publisher Piccolo.

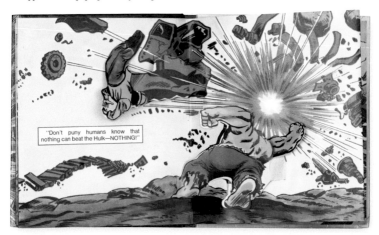

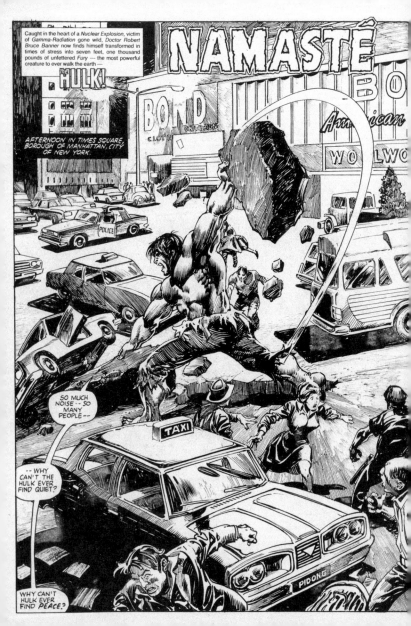

THE HULK! No. 26
Opposite: *Interior, "Namaste"; script, J.M. DeMatteis; pencils, Gene Colan; inks, Alfredo Alcala; April 1981.* Comic art veteran Gene Colan never drew the Hulk's color comic editions, but he thrived on a series of long-form black-and-white stories in *The Hulk!* magazine.

THE HULK! No. 23
Above: *Cover; pencils and inks, Walter Simonson; October 1980.*

MARVEL TREASURY EDITION No. 25
Following spread: *Cover; pencils, Al Milgrom; inks, Jack Abel; 1980.* Spidey and Hulk fought for the gold medal in super-hero theatrics in a Winter Olympics–themed Treasury extravaganza. The 64-page story was scripted by Bill Mantlo and drawn by Herb Trimpe.

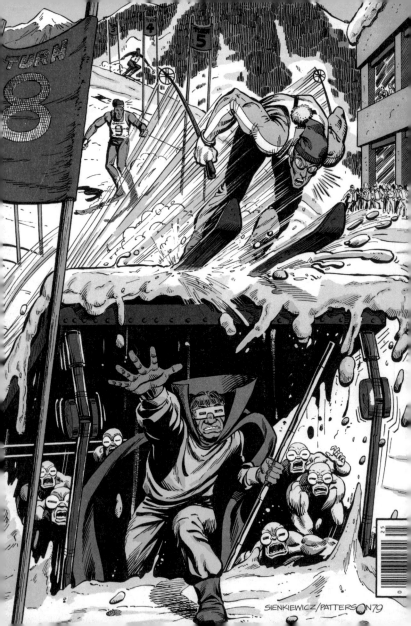

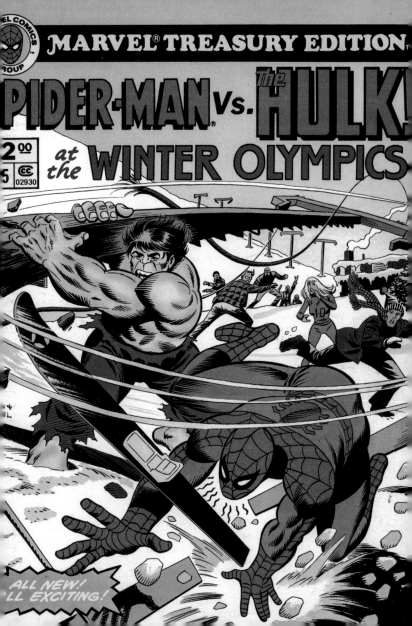

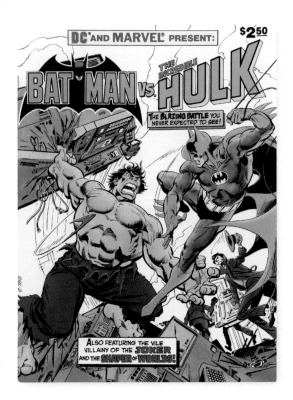

DC SPECIAL SERIES No. 27

Above: *Cover; pencils and inks, José Luis García-López; Fall 1981.*
The Hulk and Batman, as unlikely a pair as any in comics, must
team up to foil a plot by the Joker and the Shaper of the Worlds
in this DC/Marvel crossover.

MARVEL SUPER HERO CONTEST OF CHAMPIONS No. 1

Opposite: *Cover; pencils, John Romita Jr.; inks, Bob Layton; June 1982.*
The Hulk was one of countless Marvel heroes to be whisked away by
the Grandmaster to compete in a contest of skills. How did the Hulk
fare? Believe it or not, he didn't make the cut when teams were selected!

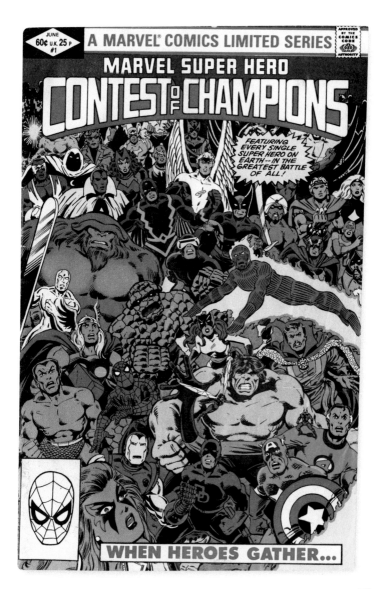

THE INCREDIBLE HULK No. 272
Below: *Interior, "Weirdsong of the Wen-Di-Go!"; script, Bill Mantlo; pencils and inks, Sal Buscema; June 1982.*

THE INCREDIBLE HULK No. 278
Opposite: Cover; pencils, Sal Buscema; inks, Al Milgrom; December 1982.
With well over 100 issues springing to life atop his drawing table from 1975 to 1985, Sal Buscema drew the Hulk longer than any other artist. "[As] far as I was concerned I would have done a 20-year run on the Hulk. I would have never let the character go."
— Sal Buscema

THE INCREDIBLE HULK No. 297
Page 116: Cover; pencils and inks, Bill Sienkiewicz; July 1984.

THE INCREDIBLE HULK No. 307
Page 117: Cover; pencils, Mike Mignola; inks, Steve Leialoha; May 1985.

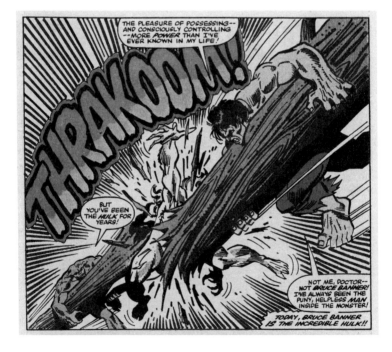

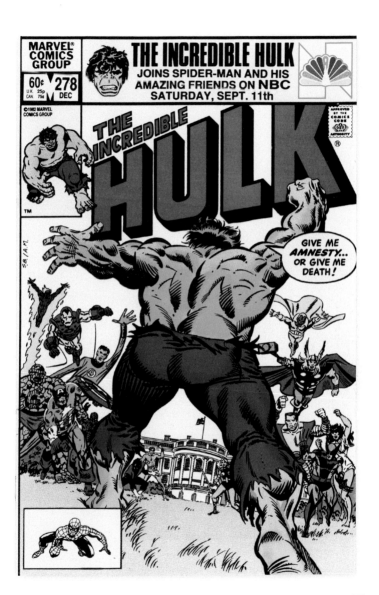

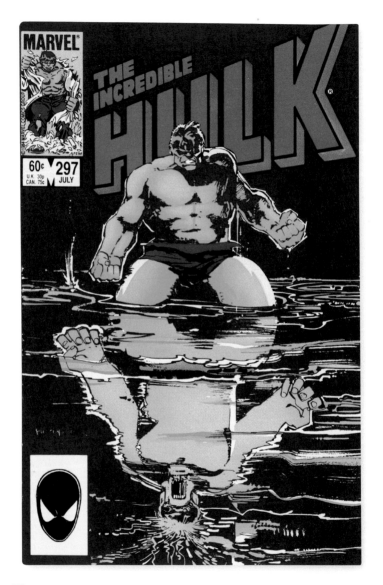

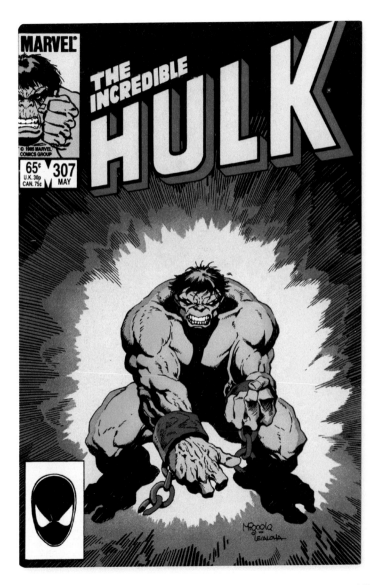

THE INCREDIBLE HULK No. 287

Below: *Cover; pencils, Ron Wilson; inks, Al Milgrom; September 1983.* The Krylorian techno-artist Bereet was a regular member of the supporting cast in Doug Moench's *Rampaging Hulk* feature. She was revived a few years later for regular Marvel continuity in Bill Mantlo's *Incredible Hulk*.

TRUTH IN ADVERTISING

Opposite: *House ad, 1981.* Marvel asked the Hulk to deliver another message to buyers, and he delivered in this *powerful* house ad.

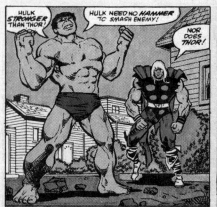

HULK **STRONGER** THAN THOR!

HULK NEED NO **HAMMER** TO SMASH ENEMY!

NOR DOES THOR!

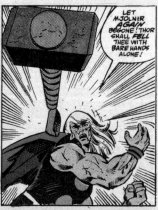

LET MJOLNIR **AGAIN** BEGONE! THOR SHALL **FELL** THEE WITH BARE HANDS ALONE!

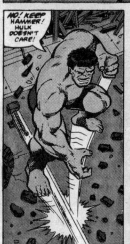

NO! KEEP HAMMER! HULK DOESN'T CARE!

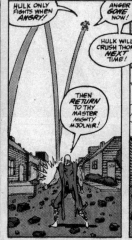

HULK ONLY FIGHTS WHEN **ANGRY!**

ANGER **GONE** NOW!

HULK WILL CRUSH THOR **NEXT** TIME!

THEN **RETURN** TO THY MASTER, MIGHTY MJOLNIR!

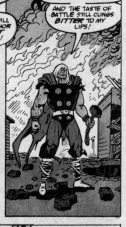

FOR ONE BRIEF MOMENT IN TIME, A **GOD** HATH FOUGHT A **MONSTER!**

AND THE TASTE OF BATTLE STILL CLINGS **BITTER** TO MY LIPS!

I, WHO AM SPRUNG FROM GODS, TURNED **SAVAGE** AS HE!

GOADED BY A LUSTING FOR **VICTORY,** MY RAGE BLINDED ME TO THE **DAMAGE,** THE **SUFFERING** THUS CAUSED!

WHAT DOTH IT MATTER WHO BE THE STRONGER? 'TWAS ME WHO EGGED THE FRAY, WHILST I HUNGERED TO BATTLE ON, IN THE NAME OF-- EMPTY PRIDE!

YEA, TO MY ETERNAL SHAME, ON THIS BLEAK DAY A **GOD** TURNED MONSTER, TOO!

END

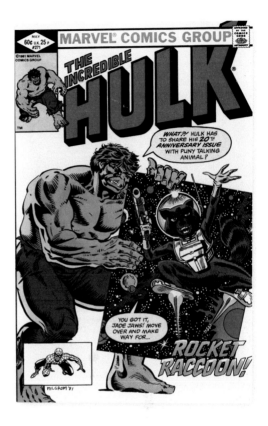

THOR No. 385

Opposite: *Interior; "Be Thou God, or Monster!"; script, Stan Lee; pencils, Erik Larsen; inks, Vince Colletta; November 1987.* Stan guest-starred as scripter of *Thor* No. 385 and once more gave his take on the ever-abiding argument of comic book fandom: "Thor vs. Hulk: Who Would Win?" This time around, Stan seemed to indicate *nobody wins.* But then, he never was able to play favorites with his cacophonous cocreations!

THE INCREDIBLE HULK No. 271

Above: *Cover; pencils and inks, Al Milgrom; May 1982.* Rocket Raccoon makes his second appearance (the first as Rocket)— six years after his first, both written by Bill Mantlo.

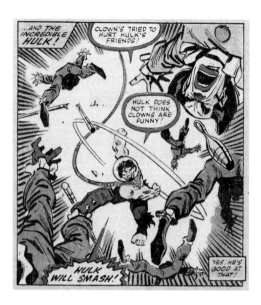

THE INCREDIBLE HULK No. 271

Above: *Interior, "Now Somewhere in the Black Holes of Sirius Major There Lived a Young Boy Named Rocket Raccoon!"; script, Bill Mantlo; pencils and inks, Sal Buscema; May 1982.* In their first irreverent team-up, Hulk and Rocket Raccoon pitted their might against the Killer Clowns.

THE INCREDIBLE HULK No. 298

Opposite: *Interior, "Sleepwalker"; script, Bill Mantlo; pencils, Sal Buscema; inks, Gerry Talaoc; August 1984.* In his search for Doctor Strange, the Hulk has the misfortune of running into Nightmare.

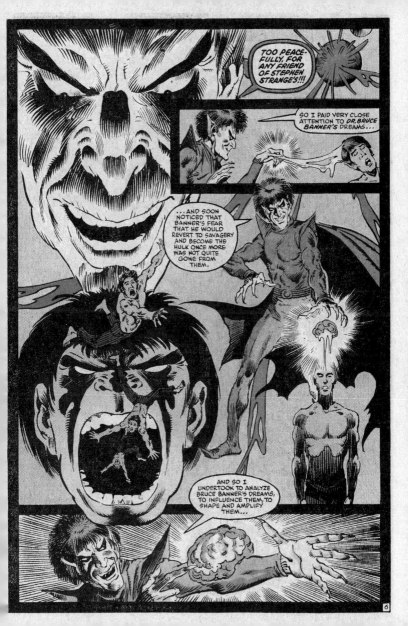

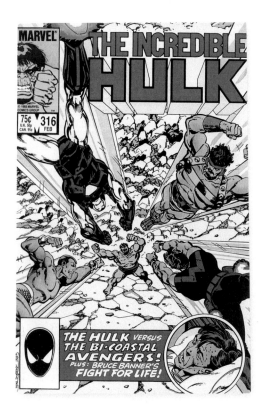

THE INCREDIBLE HULK No. 316

Above: *Cover; pencils and inks, John Byrne; February 1986.*
John Byrne wrote, penciled, and inked *The Incredible Hulk*
for only six issues but finished with a bang: the wedding of
Bruce Banner and Betty Ross.

MARVEL SUPER HEROES SECRET WARS No. 1

Opposite: *Cover; pencils, Mike Zeck; inks, John Beatty; May 1984.*
The galactic powered Beyonder gathered Marvel's most
powerful heroes and villains on Battleworld to fight it out amongst
themselves (and hopefully inspire kids to go buy the action
figures that were produced along with the series!). Bounding
into action on the side of the Avengers, the X-Men, Spider-Man,
and more was, of course, the Incredible Hulk.

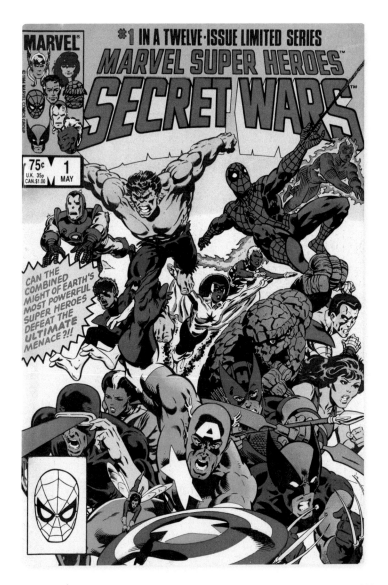

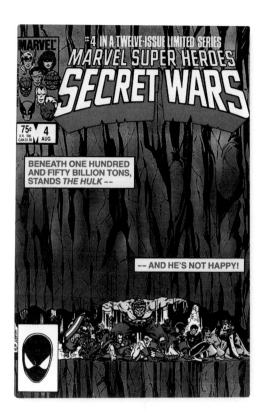

SECRET WARS COVER SKETCH

Opposite: Cover sketch; pencils, Bob Layton; inks, John Beatty; ca. 1984. An early sketch for the cover to *Marvel Super Heroes Secret Wars* No. 4 showed penciler Bob Layton giving a nod to Jim Steranko's classic cover to *Incredible Hulk Special* No. 1 (1968).

MARVEL SUPER HEROES SECRET WARS No. 4

Above: Cover; pencils, Bob Layton; inks, John Beatty; August 1984. What happens when the Molecule Man drops a mountain range on top of the heroes of *Secret Wars*? The Hulk lifts it right back up—all 150 billion tons of it in one of the most dramatic scenes in Hulk history.

THE INCREDIBLE HULK No. 288

This spread: *Interiors, "Anyone Out There Know How to Cure a Case of…Yellow Fever?"; script, Bill Mantlo; pencils, Sal Buscema; inks, Jim Mooney; October 1983.* Despite his excellent hygiene, even the Hulk has a hard time at the dentist's office!

THE INCREDIBLE HULK No. 300

Following spread: *Interior, "Days of Rage!"; script, Bill Mantlo; pencils, Sal Buscema; inks, Gerry Talaoc; October 1984.* "Probably the hardest call I ever made at Marvel was to Sal Buscema, to say, bluntly—too bluntly—'I am taking you off [*New Mutants*].' He asked why, and I said, 'You're old fashioned. This needs to be new.' And he was really mad…He turned around, and in the next issue of *The Incredible Hulk*…it was f—ing magnificent. It was like Sal was saying, 'You want to see what I can do?' He just pulled all the guns out." —Ann Nocenti

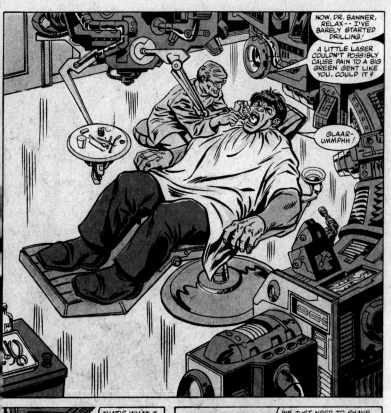

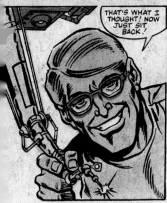

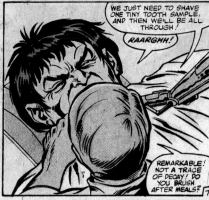

7

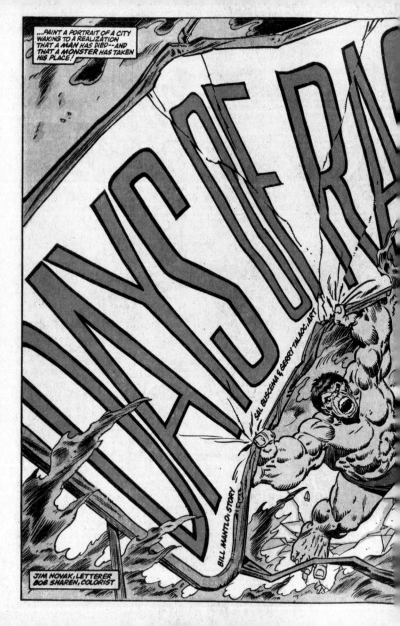

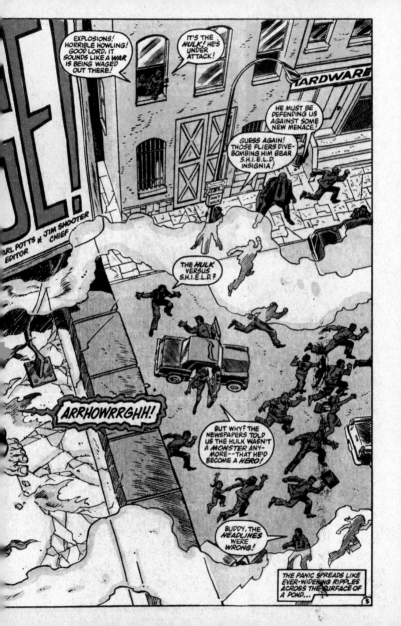

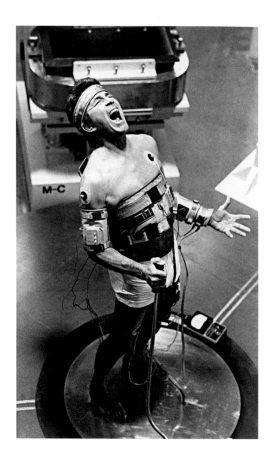

BILL BIXBY AS BRUCE BANNER

Above: *Publicity photo*, Incredible Hulk, *ca. 1977*. Actor Bill Bixby
first gained fame in the sitcoms *My Favorite Martian* and
The Courtship of Eddie's Father, but it was for his role as David
Banner in *The Incredible Hulk*, not to mention the classic catch-
phrase "Don't make me angry; you wouldn't like me when I'm
angry," that he would best be remembered.

STAN ON THE SET

Opposite: *Publicity photo*, The Incredible Hulk Returns, *ca. 1988*.

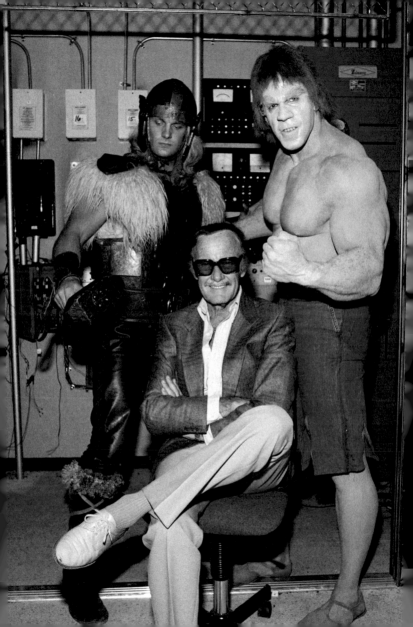

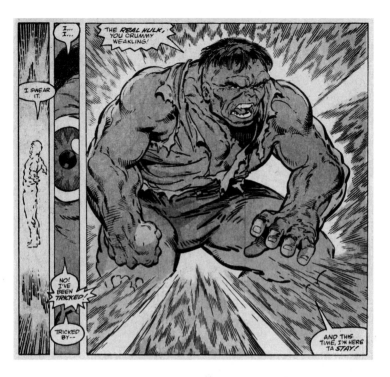

THE INCREDIBLE HULK No. 333
Opposite: *Cover; pencils, Steve Geiger; inks, Bob McLeod; July 1987.* Geiger's ominous cover foreshadows a powerful story about spousal abuse by Peter David and Todd McFarlane.

THE INCREDIBLE HULK No. 331
Above: *Interior, "Inconstant Moon"; script, Peter David; pencils, Todd McFarlane; inks, Kim DeMulder; May 1987.* Peter David was Direct Sales Manager at Marvel for three years before finally getting to take a stab at writing—a career change that has suited him quite well. He took over *The Incredible Hulk* with this issue, starting a truly *incredible* 12-year run on the title.

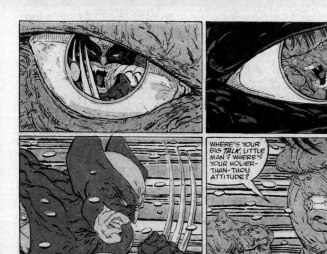

WHERE'S YOUR BIG *TALK*, LITTLE MAN? WHERE'S YOUR HOLIER-THAN-THOU ATTITUDE?

YA WANT *MORE*? C'MON, THEN... I'LL GIVE YA MORE!

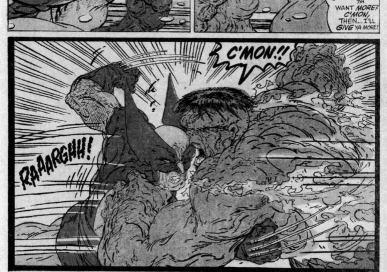

C'MON!!

RAAARGHH!

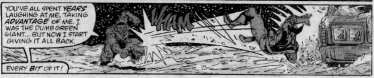

YOU'VE ALL SPENT *YEARS* LAUGHING AT ME, TAKING *ADVANTAGE* OF ME. I WAS THE DUMB GREEN GIANT... BUT NOW I START GIVING IT ALL BACK,

EVERY *BIT* OF IT!

WHAM

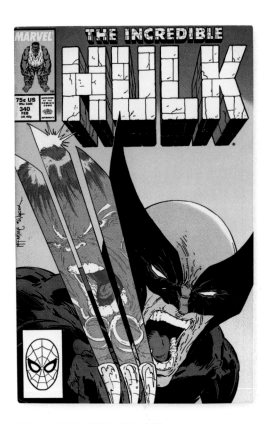

THE INCREDIBLE HULK No. 340

Opposite: *Interior, "Vicious Circle"; script, Peter David; pencils and inks, Todd McFarlane; February 1988.* A brutal rematch between the Hulk and Wolverine is delineated by young Canadian artist (and future superstar) Todd McFarlane, for whom *Incredible Hulk* was his first ongoing job at Marvel.

THE INCREDIBLE HULK No. 340

Above: *Cover; pencils, Todd McFarlane; inks, Bob Wiacek; February 1988.* It was with this issue's iconic cover that Todd McFarlane slashed his way to stardom. But this incredible run of *Incredible Hulk* is equally important to the career arc of writer Peter David, who began to turn the flagging title into a must-read monthly.

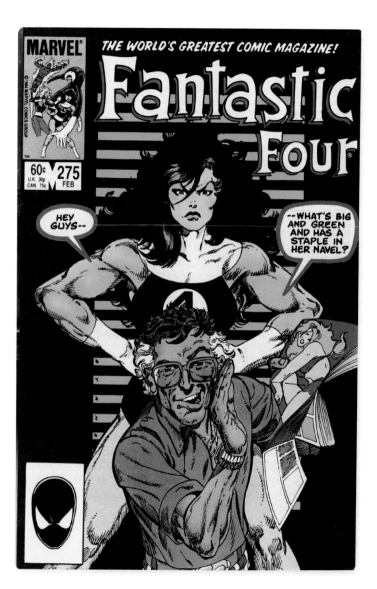

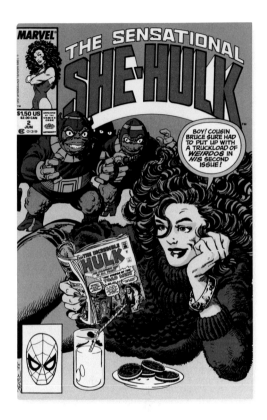

FANTASTIC FOUR No. 275

Opposite: *Cover; pencils and inks, John Byrne; February 1985.*
She-Hulk was invited to replace the Thing in the Fantastic
Four when he was off-world after the Secret Wars. In issue
No. 275, John Byrne put Stan Lee on the cover to highlight
the humorous new tone being brought to her character.

SENSATIONAL SHE-HULK No. 2

Above: *Cover; pencils, John Byrne; inks, Bob Wiacek; June 1989.*
It's safe to say that She-Hulk's first title run, while a valiant
effort, didn't latch on with readers in the early '80s. Marvel's
second attempt, however—written and drawn by John Byrne—
was a *sensation*.

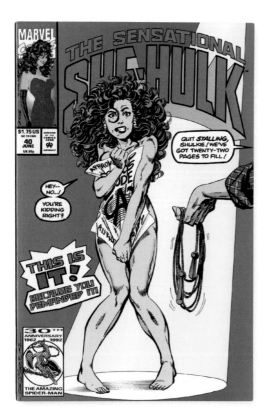

SENSATIONAL SHE-HULK No. 40

Above: *Cover; pencils and inks, John Byrne; June 1992.* Byrne served up a healthy dose of cheesecake with his side-splitting and irreverent She-Hulk stories.

SENSATIONAL SHE-HULK No. 50

Opposite: *Interior, "He's Dead?"; script, John Byrne and Michael Eury; pencils and inks, Frank Miller; April 1993.* With John Byrne leaving *Sensational She-Hulk*, he "killed himself" in issue No. 50 to set up a hilarious search for a new creative direction. Among those who "tried out" for the job was Frank Miller, who filed this noir approach to the title. (He didn't get the job.)

SUPPORTING CHARACTERS. THEY START OUT HUMBLE BUT FIRST CHANCE THEY GET THEY'RE GRABBING WHOLE SUBPLOTS.

BEFORE YOU KNOW IT THEY'RE JOCKEYING FOR A MINI-SERIES OF THEIR OWN. I'VE SEEN IT HAPPEN. IT ISN'T PRETTY.

OKAY. SO BYRNE WAS A LITTLE FULL OF HIMSELF. SO HE NEVER LET ME WEAR ANYTHING THAT DIDN'T SHOW ME OFF LIKE AN AEROBICS VIDEO.

BUT HE MADE ME LOOK GORGEOUS. HE MADE ME FEEL LIKE A WOMAN.

AND NOW HE'S DEAD AS IMPACT COMICS.

MY THOUGHTS GO WILD. MY LETTERING GOES ITALIC. THEY SAY BYRNE'S DEATH WAS AN ACCIDENT BUT I'M NOT BUYING IT. NOT FOR A SECOND. NO, THAT'S TOO EASY, TOO EASY AND TOO DARNED CONVENIENT. AND IT DOESN'T GIVE ME THE KIND OF REVENGE MOTIVE I NEED.

THERE'S SOMEBODY OUT THERE WHO'S GONNA PAY AND PAY BIG. I'LL POKE HIM IN THE EYE AND TIE HIS SHOELACES TOGETHER AND WHEN HE BEGS FOR MERCY I'LL START WITH THE TICKLING.

BECAUSE BYRNE IS DEAD AS HECK.

AND I'M MAD AS HECK.

THE INCREDIBLE HULK No. 374

Opposite: *Interior, "No Autographs"; script, Peter David; pencils, Dale Keown; inks, Bob McLeod; October 1990.* Back in the Hulk's supporting cast, Rick Jones penned his memoir, *Sidekick*, which took the fictional sales charts of the Marvel Universe by storm. Also on board the title was Dale Keown, yet another up-and-coming artist to put his stamp on Hulk with a popular and critically acclaimed run.

MARVEL ILLUSTRATED: THE SWIMSUIT ISSUE No. 1

Above: *Cover; art, Brian Stelfreeze; 1991.* Stealing a good idea from *Sports Illustrated*, *Marvel Illustrated*'s swimsuit issue was chock full of pinups of the hunkiest guys and hottest girls in the Marvel Universe. And who emblazoned the cover of the *premiere* issue? She's tall, she's green, she's sexy — she's She-Hulk!

143

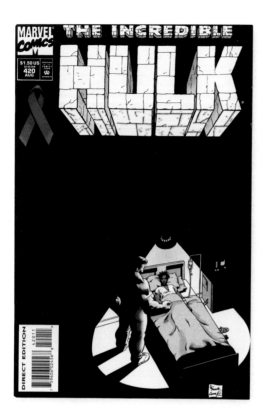

THE INCREDIBLE HULK No. 420

Above: *Cover; pencils, Gary Frank; inks, Cam Smith; August 1994.*
Gary Frank's simple yet powerful cover, adorned by an AIDS
awareness ribbon, set a somber tone for the death of long-time
supporting cast member Jim Wilson.

THE INCREDIBLE HULK No. 388

Opposite: *Interior, "Thicker Than Water"; script, Peter David;
pencils, Dale Keown; inks, Mark Farmer; December 1991.*
The *intellectual* Hulk gave Peter David more room to explore
hard-hitting issues such as the AIDS crisis with nuance and
sensitivity unlikely to be had in the "Hulk Smash" milieu.

MR. LANG...

I KNOW YOU REJECT THE IDEA... BUT MY FEELINGS FOR TYLER WERE *JUST* AS GENUINE AS YOURS. WE'VE *BOTH* LOST SOMEONE VERY PRECIOUS TO US.

TYLER WAS A *GOOD* BOY UNTIL HE MET YOU.

AND YOU'RE GOING TO *PAY* FOR WHAT YOU DID TO HIM. I KNEW IF I STAYED LONG ENOUGH AFTER MY BOY'S FUNERAL, *YOU'D* SHOW UP.

MAYBE THE *OTHERS* I HIRED TO KILL YOU SCREWED UP...

BUT *THIS* TIME, I'M OVERSEEING IT *PERSONALLY.*

BOYS! KILL THIS LITTLE F--

LANGUAGE, PLEASE. THERE *ARE* YOUNG PEOPLE PRESENT.

OH, AND YOU'LL FIND YOUR "BOYS" AREN'T *FULLY FUNCTIONING* RIGHT NOW.

AND ONCE THE COPS GET THIS *TAPE* OF YOUR THREATS...

YOU WON'T BE, EITHER.

RENO...

I MEAN, JIM *COULD'VE DIED!* SKRULLS, KREE, ROBOTS... *NO* PROBLEM, BUT STICKING MY HANDS INTO CONTAMINATED BLOOD...

NO ONE'S MAD AT YOU, RICK... EXCEPT *YOU.*

BRUCE? UHM... *HOW* DID JIM WILSON GET EXPOSED TO AIDS?

AREN'T YOU, Y'KNOW... *CURIOUS?*

WHO CARES?

NOT REALLY. IF HE HAD MEASLES, IT WOULDN'T MATTER WHERE HE GOT IT. HE'S A *FRIEND* WHO NEEDED *HELP.* YOU DO THAT FOR PEOPLE YOU *CARE* ABOUT. THAT'S WHY HE WAS THERE FOR ME WHEN I NEEDED *HIM...*

...AND WHY RICK AND I WERE THERE FOR HIM...

...AND WHY *I'LL* ALWAYS BE THERE FOR *YOU.*

NO MATTER WHAT.

MMMWAAAA.

NEXT ISSUE!

MAN-THING

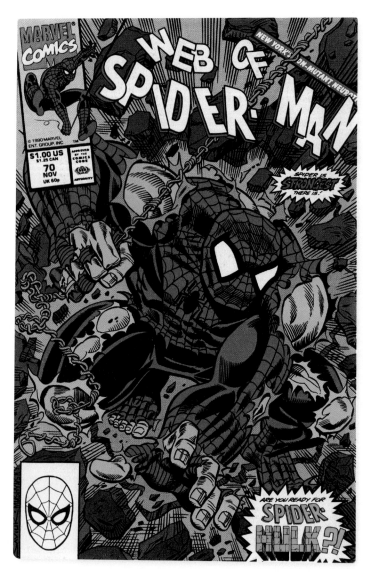

146

WEB OF SPIDER-MAN No. 70

Opposite: *Cover; pencils, Alex Saviuk; inks, Andy Mushynsky; November 1990.* Everyone wants to be the Hulk! And when Peter Parker absorbed power drained from Bruce Banner, readers had to be ready for Spider-Hulk!

THE INCREDIBLE HULK No. 400

Above: *Cover; pencils, Dale Keown; inks, Mark Farmer; December 1992.* In the early 1990s, any excuse was seized for a gaudy gimmick cover — and the Hulk's "400th issue special" is a suitably incredible example.

THE INCREDIBLE HULK No. 474

Above: *Cover; pencils and inks, Javier Pulido: March 1999.* Two things comic book companies can't get enough of are homage covers and series relaunches. So when the *Incredible Hulk* series "ended" (to be swiftly followed by a new No. 1), it was fitting for Javier Pulido to pay tribute to Jack Kirby's iconic first-ever Hulk cover.

AVENGERS ANNUAL No. 20

Opposite: *Interior, "Marvel Masterwork Pin-Up"; pencils and inks, Mike Mignola; 1991.* The visionary creator of Hellboy, Mike Mignola, treated fans to his unique interpretation of the Hulk — and the rest of the original Avengers, plus Loki — in this bonus pinup.

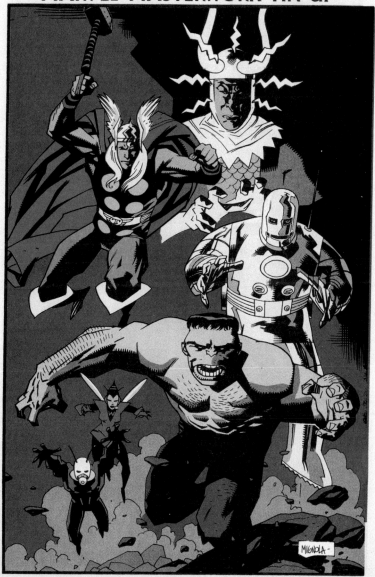

THE INCREDIBLE HULK No. 377

Opposite: *Cover; pencils, Dale Keown; inks, Bob McLeod; January 1991.*

HULK: FUTURE IMPERFECT No. 1

Above: *Interior, "Future Imperfect"; script, Peter David; pencils and inks, George Pérez; December 1992.* The landmark two-issue, prestige format *Hulk: Future Imperfect* offered readers—and Bruce Banner—a vision of a nightmarish future where an aged Hulk rules the world as the monstrous Maestro.

HULK: FUTURE IMPERFECT No. 1

Following spread: *Interior, "Future Imperfect"; script, Peter David; pencils and inks, George Pérez; December 1992.*

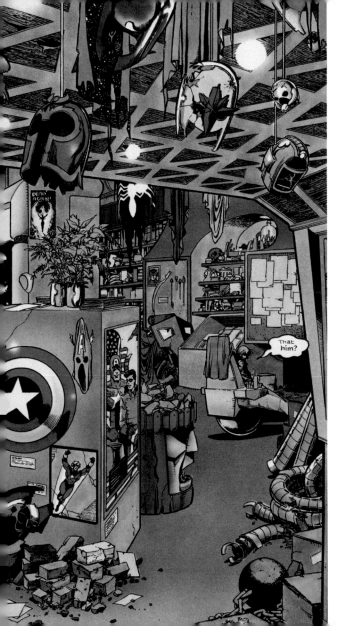

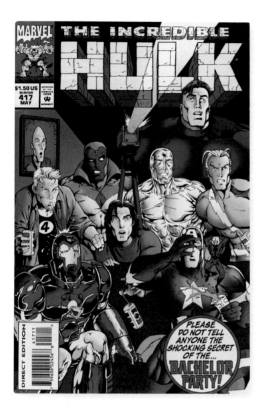

THE INCREDIBLE HULK No. 417

Above: *Cover; pencils, Gary Frank; inks, Cam Smith; May 1994.*
A host of heroes showed up for Rick Jones's bachelor party —
and his bride Marlo's bachelorette party — in perhaps the most
hilarious *Incredible Hulk* story ever printed.

THE AGE OF MARVELS

Opposite: *Marvels concept art; art, Alex Ross; 1994.* Painter Alex
Ross established himself as a comic book superstar with
Marvels, delivering a retrospective take on a Marvel Universe
more realistically rendered than anything fans had seen
before. Naturally, the Hulk played his part — including Ross's
depiction of a battle with his old foe, Zzzax. Bruce Banner and
his monstrous alter ego took their place in the Marvel pantheon
in this concept art published in *Marvels* No. 0 (August 1994).

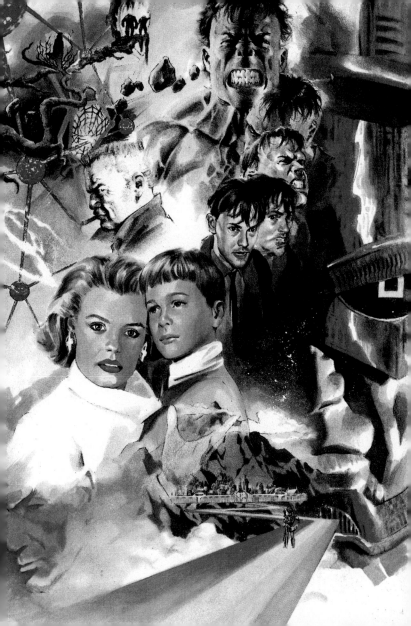

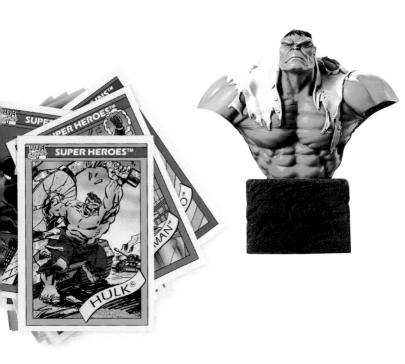

MARVEL UNIVERSE TRADING CARDS
Above left: *Trading cards, Impel, 1990.* Marvel's first set of cards contained 162 cards and five hologram "chasers." The sets included "rookie cards" of each year's new heroes.

HULK MINI-BUST
Above right: *Bowen Designs Marvel Mini-Bust, 1998.* Sculptor Randy Bowen's company Bowen Designs produced hundreds of resin statues and so-called "mini-busts" of Marvel's characters —and, of course, the Hulk was one of the first.

THE INCREDIBLE HULK No. 463
Opposite: *Cover; pencils and inks, Adam Kubert; April 1998.* Peter David's epic 12-year run as *Incredible Hulk* writer came to an end with a year-long collaboration with Adam Kubert. The artist—son of industry legend Joe Kubert, who even lent a hand on some issues!—delivered an action-packed take on the character. Kubert's blockbuster pencils were ideal to send David off his legendary tenure on the book with a bang.

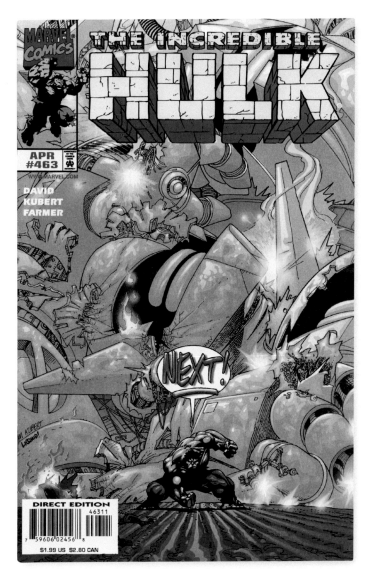

IT DOES THAT OFTEN THESE DAYS. I CAN SIT AND WATCH IT FOR HOURS, BECAUSE WHEN IT VANISHES AND DARKNESS FALLS UPON ME, IT'S STILL EMBEDDED IN MY MIND.

MY NAME IS BRUCE BANNER. I AM OVER TWO HUNDRED YEARS OLD, I THINK.

INCREDIBLE HULK: THE END No. 1
Previous spread: *Interior, "The Last Titan"; script, Peter David; pencils, Dale Keown; inks, Jon Livesay and Joe Weems; August 2002.* In a "What If?" style bit of speculative fiction, Bruce Banner is the last person alive on a postapocalypse earth. He is determined to end his life—but will the Hulk let him?

INCREDIBLE HULK No. 38
Above: *Cover; pencils and inks, Kaare Andrews; May 2002.*

ARE YOU READY FOR YOUR CLOSE-UP, HULK?
Opposite: *Movie poster, Hulk, Universal Pictures, 2003.* Titled simply *Hulk*, Universal brought the big green one to cinemas in a film directed by Ang Lee and featuring Eric Bana as Bruce Banner. It raked in $245 million worldwide.

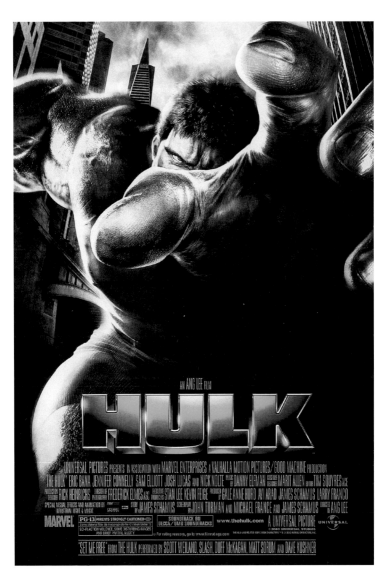

AN ANG LEE FILM

HULK

161

THE HULK GOES POSTAL

Right: *Hulk postage stamp; pencils, John Buscema; inks, Rich Buckler; United States Postal Service; 2007.* The United States Postal Service unveiled a book of 20 *Marvel Super Heroes* stamps that included their most high-profile heroes. For a mere 41 cents, the Hulk agreed to distribute letters across the US.

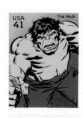

THE INCREDIBLE HULK No. 82

Below: *Interior, "Dear Tricia"; script, Peter David; pencils and inks, Jae Lee; August 2005.*

THE HULK No. 11

Opposite: *Cover; pencils and inks, Phil Noto; April 2015.* Phil Noto mimics *Time* magazine in his cover to *The Hulk* No. 11.

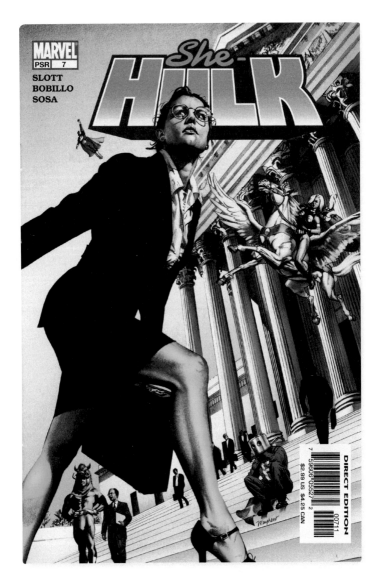

SHE-HULK No. 7
Opposite: *Cover; pencils and inks, Mike Mayhew; November 2004.* Dan Slott's 2004 revival of *She-Hulk*, her first ongoing title since *Sensational She-Hulk* wrapped up in 1994, was a critically acclaimed success, focusing heavily on her hijinks as an attorney.

YOUNG AVENGERS No. 4
Above: *Interior, "Deus Ex Machine Gunner"; script, Kieron Gillen; pencils and inks, Jamie McKelvie and Mike Norton; June 2013.* A brand new "Hulk" made the scene in *Young Avengers*. Hulkling was the love child of Captain Mar-Vell and Skrull princess Anelle, raised on Earth by a Skrull nurse posing as an earthwoman, ignorant of the facts of his own birth. He took the form of the Hulk as a form of hero worship of the big green guy, and also developed a romantic relationship with Wiccan, the son of Vision and the Scarlet Witch.

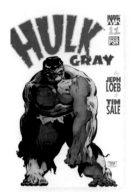
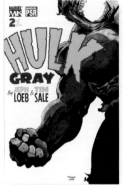
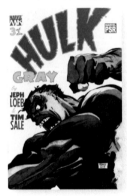
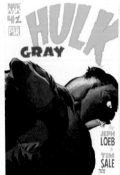

HULK: GRAY Nos. 1–4

Above: *Covers; pencils, inks, and colors, Tim Sale; December 2003–February 2004.* Jeph Loeb and Tim Sale collaborated on what came to be known as their "color series" with *Daredevil: Yellow* (2001) and *Spider-Man: Blue* (2002). *Hulk: Gray* followed in 2003, and like the other two series was a melancholy flashback tale rooted in the character's gray days: A psychiatric session with Dr. Leonard Samson dredges up memories of the abusive Thunderbolt Ross and the love of his life, the general's daughter, Betty.

HULK: GRAY No. 5

Opposite: *Uncolored cover; pencils and inks, Tim Sale; March 2004.*

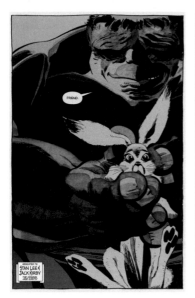
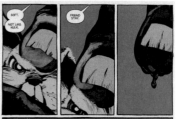
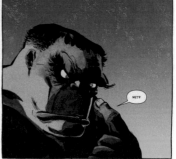

HULK: GRAY No. 3

This spread: *Interiors, "C Is for Cry"; script, Jeph Loeb; pencils and inks, Tim Sale; January 2004.* In a scene hearkening back to Hulk's roots in *Frankenstein* lore, the gray Hulk kills a pet rabbit he took as his pet, his failed attempts at tenderness feeding the rage building inside of him.

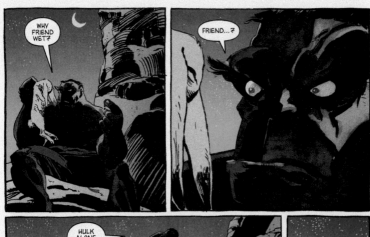
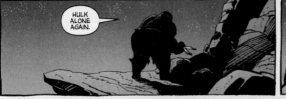

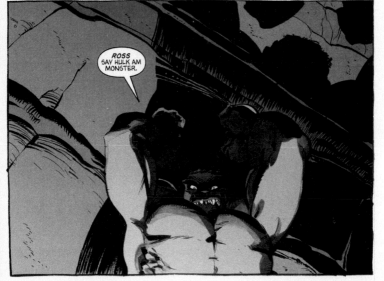

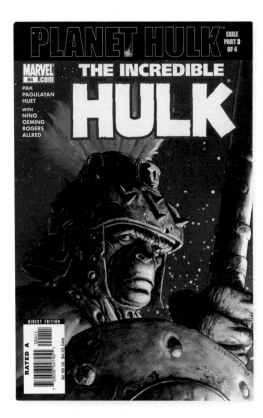

THE INCREDIBLE HULK No. 94

Above: *Cover; pencils and inks, Ladrönn; June 2006.* In an act of treachery from his "friends" in the Illuminati, Hulk is given a one-way ticket into outer space, the better to solve the problem of his rampages once and for all. He winds up on another planet, cast as a gladiator in a ruthless tyrant's games against myriad exotic alien species — a new world in which Hulk can once again prove who is the strongest of all. And he does.

THE INCREDIBLE HULK No. 102

Opposite: *Interior; "Planet Hulk: Allegiance Part 3"; script, Greg Pak; pencils, Aaron Lopresti; inks, Sandu Florea; March 2007.* The Hulk turns his exile to his advantage, overturning the rule of the vicious Red King.

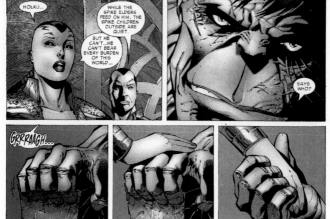

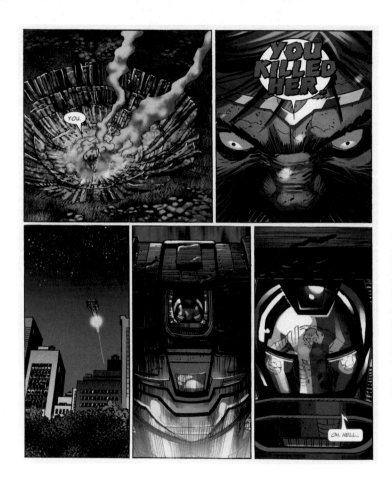

WORLD WAR HULK No. 1

This spread: *Interiors, "World War Hulk Chapter 1"; script, Greg Pak; pencils, John Romita Jr; inks, Klaus Janson; August 2007.* In *World War Hulk*—a direct sequel to *Planet Hulk*—the Hulk sets a course from Sakaar to Earth for the most murderous of reckonings with the Illuminati, including Iron Man, for whom even the biggest, beefiest Hulkbuster armor yet would not suffice.

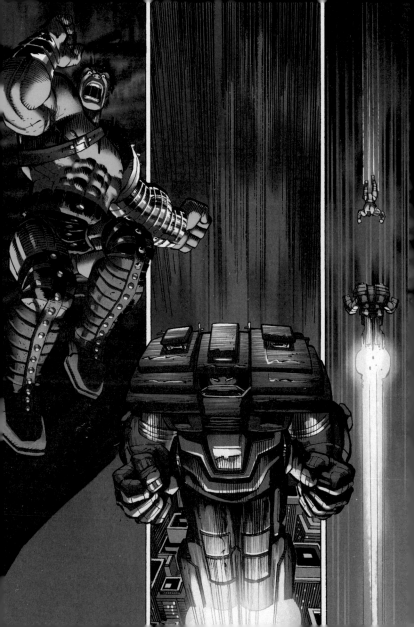

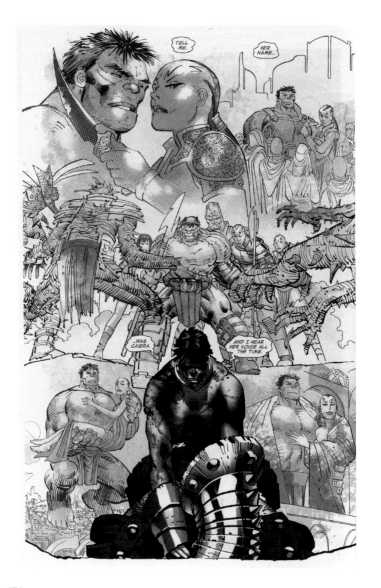

WORLD WAR HULK No. 3
Opposite: *Interior, "World War Hulk Chapter 3"; script, Greg Pak;
pencils, John Romita Jr; inks, Klaus Janson; October 2007.*

WORLD WAR HULK No. 5
Above: *Interiors, "World War Hulk Chapter 5"; script, Greg Pak;
pencils, John Romita Jr; inks, Klaus Janson; January 2008.*

HULK No. 23

Above: *Cover; pencils, Ed McGuinness; inks, Mark Farmer; August 2010.* The mystery of the Red Hulk's identity was revealed in the "World War Hulks" event: Hiding behind the crimson visage of the Red Hulk was none other than (in an ironic twist spoiler!), the greatest Hulk-hunter of all time, General "Thunderbolt" Ross. And the Red She-Hulk? (Yeah, one of them, too!) Why, that was the general's daughter, Betty Ross.

HULK No. 1

Opposite: *Cover; pencils, Ed McGuinness; inks, Dexter Vines; February 2008.* The Red Hulk debuts in *Hulk* No. 1.

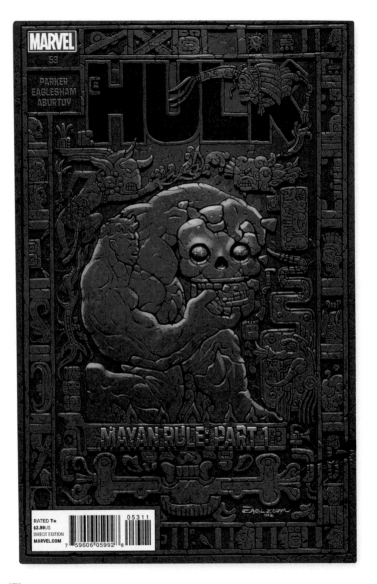

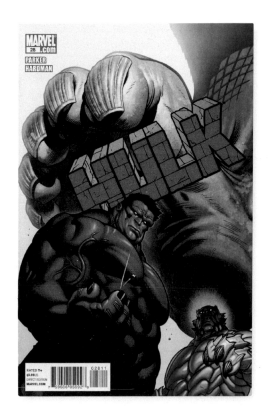

HULK No. 53

Opposite: *Cover; pencils and inks, Dale Eaglesham; August 2012.*
In 2012, the alleged year of the Mayan-predicted world
apocalypse, writer Jeff Parker and artist Eaglesham had fun
with the concept in the final story arc of their *Hulk* series.

HULK No. 28

Above: *Cover; pencils and inks, Ed McGuinness; February 2011.*

CINEMATIC HULK
Top: *Movie still*, The Incredible Hulk, *Marvel Studios/Universal Pictures, 2008*. Marvel Studios follows up *Iron Man* with the Universal-distributed *The Incredible Hulk* reboot starring Edward Norton. Not quite the blockbuster that *Iron Man* was, it still cemented the Hulk as an integral part of Marvel Cinematic Universe (MCU) storytelling.

RAGE OF THE HULK
Above: *Movie still*, The Incredible Hulk, *Marvel Studios/Universal Pictures, 2008*. On the run, in hiding in Rio de Janeiro, Edward Norton's Bruce Banner begins the film attempting to control his breathing through yoga. Unfortunately for all involved, this is not a long-term solution. The CGI Hulk managed a path of box office destruction to a $263 million worldwide take.

THE INCREDIBLE HULK
Opposite: *Movie poster*, The Incredible Hulk, *Marvel Studios/Universal Pictures, 2008*.

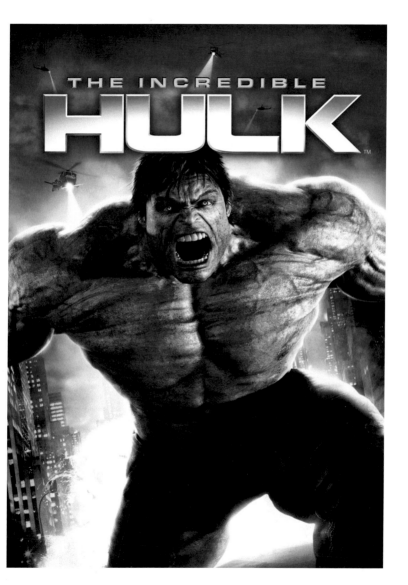

INCREDIBLE HULK No. 41

Above: *Cover; pencils and inks, Kaare Andrews; August 2002.*
Andrews's *smash crackle pop* Hulk cover made comic book
buyers second guess whether they were in a comic book store
or grocery aisle.

PLANET HULK No. 1

Opposite: *Baby variant cover; pencils and inks, Skottie Young;
July 2016.* Artist Skottie Young gained fame in part for
his cartoonish "baby" covers that transformed well-known
characters of Marvel into adorable infant versions, including
the super-cute 'lil Hulk family.

THE INCREDIBLE HULK No. 7
Opposite: *Avengers Art Appreciation variant cover: pencils and inks, Charles Paul Wilson II; June 2012.*

INCREDIBLE HULK No. 49
Above: *Cover: pencils and inks, Kaare Andrews; March 2003.* Andrews's homage to Maurice Sendak's *Where the Wild Things Are.*

TOTALLY AWESOME HULK No. 3

Opposite: *Interior, "Cho Time: Part Three"; script, Greg Pak; pencils and inks, Frank Cho; April 2016.* Greg Pak returned to the world of the Hulk and it was Totally Awesome! Boy genius, Hercules sidekick, and Banner groupie Amadeus Cho assumes the mantle of the Hulk, and manages to keep his power and intellect on the same page—most of the time!

AMADEUS CHO IS . . . THE TOTALLY AWESOME HULK!

Above: *Variant cover; Totally Awesome Hulk No. 3; pencils and inks, Michael Cho; April 2016.* There are a lot of Totally Awesome Chos: Amadeus stars in the book, the artist is Frank, and this variant cover was even designed and drawn by Michael Cho.

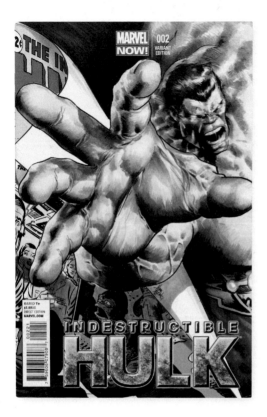

INDESTRUCTIBLE HULK No. 2

Above: *Cover; pencils and inks, Leinil Francis Yu; February 2013. Incredible, Rampaging, Savage,* adjectiveless…Marvel adds another epithet to the Hulk with the 2013 series by writer Mark Waid and Leinil Yu, *Indestructible Hulk*.

AVENGERS VS. X-MEN No. 11

Opposite: *Interior; script, Brian Michael Bendis; pencils, Olivier Coipel; inks, Mark Morales; November 2012.* The Avengers take on an X-Men squad led by a Cyclops that has been corrupted by the Dark Phoenix Force. And in such climactic battles between the heaviest hitters of the Marvel Universe, it's always helpful to have a Hulk on your side.

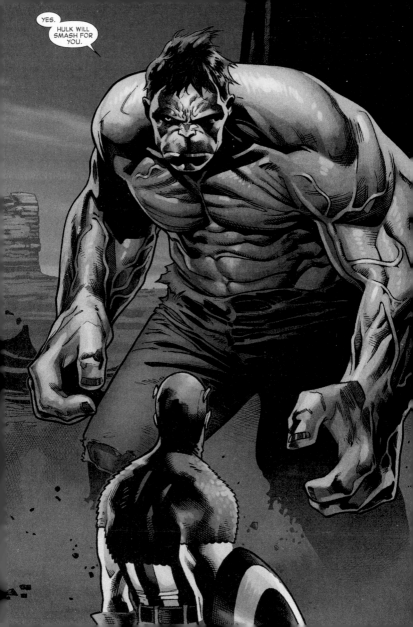

THE INCREDIBLE HULK No. 102
Front cover: *Cover art; pencils, Marie Severin; inks, Frank Giacoia; April 1968.* After years of costarring in *Tales to Astonish*, the Hulk returned to a full-length comic of his own. After Marvel expanded its line, *Hulk* became one of its most popular titles.

INCREDIBLE HULK ANNUAL 2001
Opposite: *Interior; "Hulk vs. Rain"; script, pencils, and inks, James Kochalka; 2001.*

SAVAGE HULK No. 1
Back cover: *Variant cover; art, Alex Ross; August 2014.*

All images in this volume are © Marvel unless otherwise noted. Any omissions for copy or credit are unintentional and appropriate credit will be given in future editions if such copyright holders contact the publisher.

CREDITS
The majority of the comics included in this volume were photographed from the collections of Bob Bretall, Nick Caputo, Marvel, Barry Pearl, Colin Stutz, Michael J. Vassallo, and Warren Reece's Chamber of Fantasy. Also: Jesse and Sylvia Storob. Courtesy Ivan Briggs: 72. Courtesy Dewey Cassell: 54. Courtesy Everett Collection: 132. Getty Images/Silver Screen Collection: 88. © Marvel, courtesy Mike Burkey/ www.romitaman.com: 91, 167. © 2018 Marvel/Imaged by Heritage Auctions, HA.com: 7, 25–26, 29, 56, 67–68, 80, 94–95, 102. © Marvel, courtesy Tellshiar: 38 (right), 41, 74, 103 (top). © 2018 Marvel/Courtesy Todd Sheffer/Hake's Americana: 82–83. Marvel Studios TBC: 180–181. Moviestore collection Ltd / Alamy Stock Photo: 107 (above). Courtesy of the Patterson Family Trust: 40. © picture alliance/AP Images/ Nick Ut: 133. Copyright © Rolling Stone LLC 1971. All Rights Reserved. Used by Permission: 55. TAM Collection: 58, 90, 92, 97, 156 (right), 161. Courtesy Tellshiar: 37, 93.

MARVEL

© 2018 MARVEL
marvel.com

TASCHEN GMBH
Hohenzollernring 53, D-50672 Köln
taschen.com

Editor/art director: Josh Baker, Oakland
Design/layout: Jess Sappenfield, Oakland
Editorial coordination: Jascha Kempe, Cologne; Nina Wiener and Sarah Wrigley, New York
Production: Stefan Klatte, Cologne
German translation: Reinhard Schweizer, Freiburg
French translation: Eric Andret, Paris
Editorial consultants: Jess Harrold, John Rhett Thomas, and Scott Bryan Wilson
Special consultant to Roy Thomas: Danny Fingeroth

EACH AND EVERY TASCHEN BOOK PLANTS A SEED!
TASCHEN is a carbon neutral publisher. Each year, we offset our annual carbon emissions with carbon credits at the Instituto Terra, a reforestation program in Minas Gerais, Brazil, founded by Lélia and Sebastião Salgado. To find out more about this ecological part-nership, please check: *www.taschen.com/zerocarbon*
Inspiration: unlimited.
Carbon footprint: zero.

To stay informed about TASCHEN and our upcoming titles, please subscribe to our free magazine at *www.taschen.com/magazine*, follow us on Twitter, Instagram, and Facebook, or e-mail your questions to *contact@taschen.com*.

Printed in Italy
ISBN 978-3-8365-6785-5